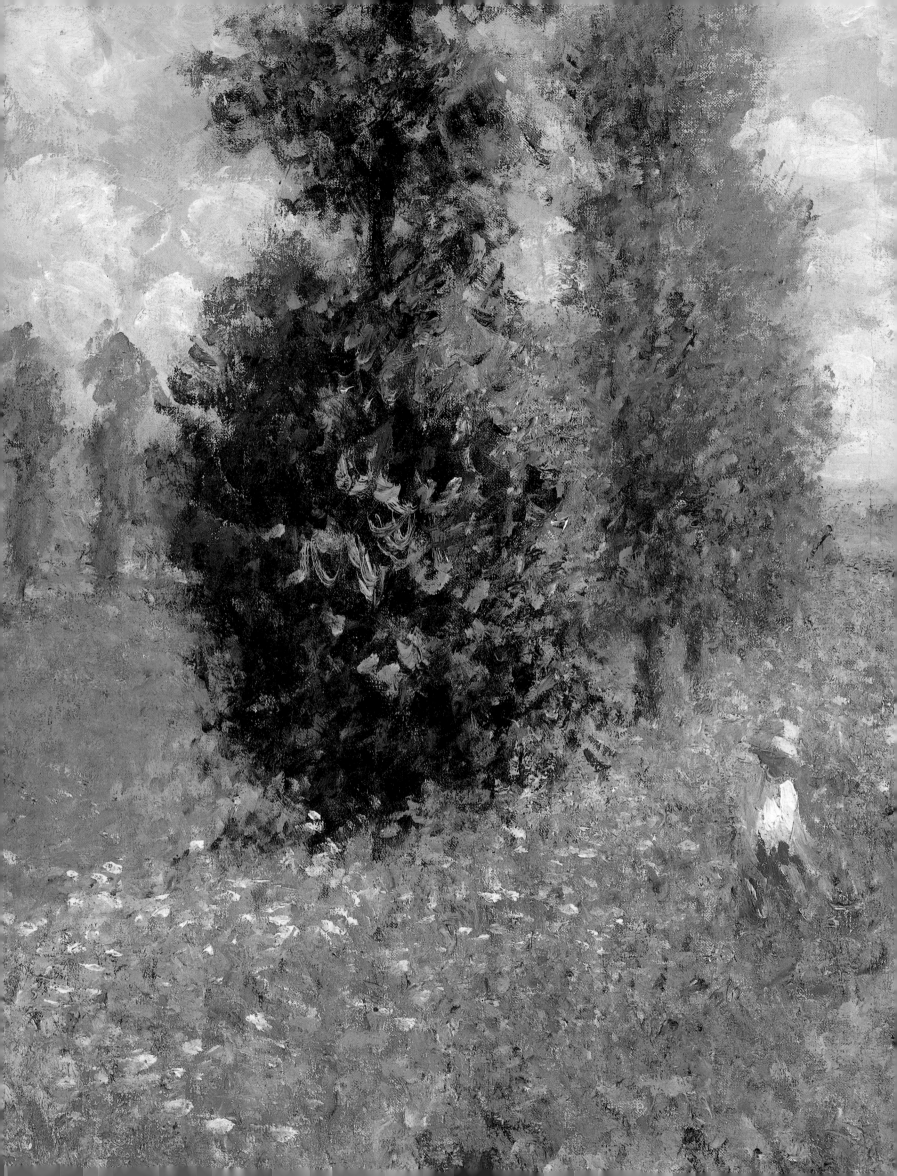

Art
IN BLOOM

ELLA M. FOSHAY

with paintings from the
Museum of Fine Arts, Boston

PHAIDON UNIVERSE · NEW YORK
PHAIDON · OXFORD

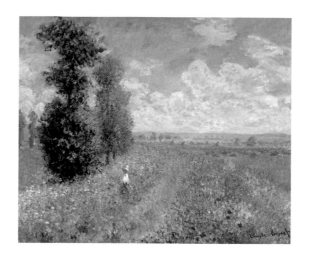

Oscar Claude Monet
French, 1840–1926
Meadow with Poplars
Oil on canvas, 21½ x 25¾ inches
Bequest of David P. Kimball
in Memory of his wife, Clara Bertram Kimball. 23.505

Published in the United States of America in 1990
by Phaidon Universe
381 Park Avenue South, New York, NY 10016

© 1990 Universe Publishing Inc.

Library of Congress Cataloging-in-Publication Data
Foshay, Ella M., 1948–
 Art in bloom / Ella M. Foshay.
 p. cm.
 ISBN 0-87663-603-2
 1. Flowers in art. 2. Painting. 3. Watercolor
 painting.
 I. Title
ND1400.F67 1990
758′.42′09 — dc20 90–7199
 CIP

Cover and Book Design: Christina B. Bliss
Floral Dingbats: Courtesy of Jane Gardner

Published in Great Britain in 1990
by Phaidon Press Limited
Musterlin House, Jordan Hill Road,
Oxford 0X2 8DP

ISBN 0-7148-2692-8

A CIP catalogue record for this book is available
from the British Library.

90 91 92 93 94 / 10 9 8 7 6 5 4 3 2 1

Printed in Singapore

TABLE
OF
CONTENTS

THE
FLOWER
OBSERVED

ELLA M. FOSHAY

Consider the lilies of the field, how they grow;
they toil not, neither do they spin:
* And yet I say unto you, That even Solomon in all*
his glory was not arrayed like one of these.

Matthew 6:28, 29

Through the centuries, artists did not need to be exhorted to observe the beauty of flowers and reflect upon their concealed meanings. Spontaneously and consistently, they responded to the resplendent, gratuitous grace of floral forms and explored and considered the life cycle of plants as a metaphor for the human condition. They were not alone in this search, but were joined by poets, philosophers, natural scientists, writers, gardeners, and all those who were sensitive to the call of nature. Whether their objective was practical — if they were seeking the curative property of digitalis — or symbolic — if they were painting a lily as a symbol of the Virgin Mary —

they shared a belief that essential truths could be found through the consideration of the floral kingdom. The mysterious truths that were embraced within the petals of a small flower inspired the romantic poet Alfred, Lord Tennyson to write:

Flower in the Crannied Wall
I pluck you out of the crannies,
I hold you here, root and all,
 in my hand,
Little flower — but if I could
 understand
What you are, root and all, and
 all in all,
I should know what God and man is.[1]

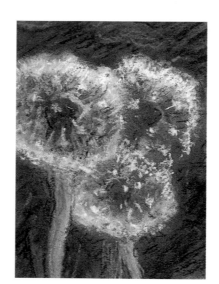

Of the two basic approaches to the study of plants from ancient times — one philosophical and the other utilitarian — we can assume that the practical came first. Plants provided essential food for survival as well as medicinal products for maintaining health. One of the most important sources for the development of plant illustration in the western world was the herbal. In antiquity the herbal originated not as a tract on natural history, but as a descriptive drug list or a manual of medicine. By medieval times, herbals began to include descriptions of plant "virtues" as well as their properties. A curious blend of pseudoscientific documentation, symbolism, and decorative fancy ensued in both the texts and the illustrations of these herbals. One could find, for example, a drawing of a narcissus in the *Ortus sanitatis* (1491), in which a specimen of the plant, suspended on a blank page, sprouts small human torsos from its buds. In this case, the anthropomorphic plant probably refers to the classical legend of Narcissus, who fell in love with a reflection of himself. The composite image of flowers and human forms would later appear in the painting and graphic work of Odilon Redon for its suggestive potential and without specific mythological reference.

In 15th-century Europe, Renaissance painters and illustrators of books produced images of flowers that were characterized by unprecedented realism. The Master of Mary of Burgundy, an artist from the Netherlands, framed his *Book of Hours* illustrations with a gold border that served as a kind of royal carpet for a variety of brilliant flowers, including daisies, violets, and pinks. The flowers were depicted with such exquisite *trompe l'oeil* realism, including cast shadows, that they invite us to pluck them from the page. With a twist of humor, the artist pretends that a dragonfly was so deceived and has settled on a daisy to extract its nectar.

Along with studies of human anatomy, the pages of Leonardo da Vinci's notebooks were filled with notations and drawings reflecting his preoccupation with the appearances of the plant world and its organic life. Although the artist's images

Flos Solis maior.

of flowers are suspended on a blank page in the manner of a botanical drawing, their robust three-dimensionality infuses them with the breath of life. A drawing of a Star of Bethlehem, shown with writhing ribbony leaves and a fully modeled floral blossom, reflects Leonardo's study and explanation of how vegetation is affected by the nature of the ground that supports it. Although the soil is not described in the drawing, it is implied by the taut stems of the flowers which indicate that the plant is securely rooted in the earth. It is clear from this image that Leonardo took to heart the warning that he gave to fellow painters in his *Treatise on Painting.* "To avoid the condemnation of those who know these matters," wrote Leonardo, "be prepared to represent everything from nature."[2]

The fascination with the relationship of flowers and their environment is eloquently described by Albrecht Dürer in his *Great Piece of Turf,* painted in 1503. This small watercolor and gouache drawing represents a variety of wild grasses growing from the earth beside a small pool of water in which faint reflections of the dandelions, plantains, yarrow, and panicle grass can be seen. So unstructured and intense is Dürer's close-up view of the ordinary clod of soil, which he found in the Jura Mountains near Nuremberg, that he virtually erases himself from the painting. According to Leonardo, painting nature required a virtual loss of the artist's self and compelled "the mind of the painter to transform itself into the very mind of nature."[3] Dürer successfully accepted the challenge.

Just before 1600, Flemish and Dutch artists produced the earliest examples of full-scale easel paintings that represented bouquets of flowers arranged in vases. Earlier floral arrangements had appeared as symbolic accessories in religious images reinforcing or enriching the spiritual message of the central subject. Images of the Virgin Mary in early Netherlandish painting sometimes included majolica vases containing white lilies, irises, and columbines. The Madonna lily is a religious attribute that symbolizes the purity of Christ's Mother as well as of Christ himself

and might be carried like a sceptre in the hand of the angel of the Annunciation. The iris, *la fleur de lis,* because of its purple color is a symbol of royalty, and suggests the Virgin's divine role as the Queen of Heaven. The columbine signified the Holy Ghost, and other small plants such as violets came to be regarded as general symbols of Christian faith and humility. When Netherlandish artists extracted these floral still lifes from their religious settings and began to paint them as independent subjects, the symbolic implications remained a potent part of their expressive content.

Flowers were also included in still-life compositions, called *Vanitas* paintings, which contained ripe fruit, candles, books, and human skulls. These objects were treated as emblems of death and moral reminders to the viewer to lead a good life devoted to the spiritual principles of Christianity. It is obvious that a skull is a symbol of mortality and that a burning candle can connote the transience of life. It is more subtle and poignant to view the exquisite beauty of a flower in full bloom as a symbol of impending decay. The biblical association of flowers with the *vanitas* theme could be found by artists in Isaiah 40:6, which warned that "All flesh is grass, all the goodliness thereof is as the flowers of the field: the grass withereth, the flower fadeth; because the spirit of the Lord bloweth upon it." Sometimes an insect or butterfly alights on a flower or a precarious dewdrop rests on a leaf in a painted bouquet by such Netherlandish painters as Ambrosius Bosschaert or Jan van Huysum to reinforce the notion of the fleeting quality of natural and, by association, human life.

Gardening became a passion for Dutch merchants and art patrons in the 17th century. As a consequence of these merchants' gardening tastes, rare cultivated blossoms began to increase the floral variety and abundance in still-life painting. Tulips, for example, were imported from the Near East and became so popular in Dutch horticultural circles that speculation in the bulbs brought prices to a level unprecedented in the history of gardening. This so-called tulipomania, or gambling in

tulip bulbs, reached such a frenzy that one 'Viceroy' bulb was exchanged for: "2 loads of wheat; 4 loads of rye; 4 fat oxen; 8 fat pigs; 12 fat sheep; 2 hogsheads of wine; 4 barrels of 8-florin beer; 2 barrels of butter; 1,000 lbs. of cheese; a complete bed; a suit of clothes and a silver beaker."[4] Tulips, therefore, which appear so frequently in Dutch flower pieces, such as those by van Huysum, are both emblems of horticultural delight and stern symbols of the consequences of greed. Still-life artists present us with a paradox. Although they represent flowers, nature's gems, in all their beauty for our delectation, they entreat us not to indulge in such sensuous pleasures but view them instead as sermons preaching the necessity of leading a moral life in anticipation of death. Lest we imagine that the delight in the tulip was confined to Holland itself, let us not forget that the Dutch were the first to settle in New York. They brought bulbs with them and established the tulip as a popular garden variety in the new world. A *New York Evening Post* article, dated May 17, 1831, recorded that "the fondness for the cultivation of tulips, for which the Dutch founders of New York were distinguished, is not yet extinct. The plantations of this splendid flower, have changed their location. Formerly tulips were cultivated on the soil which now covers the north part of Trinity Church Yard, when it was without the city—at present the finest beds are some miles to the northward and eastward of the place."

Naturalism in western flower painting depended on advances in science which had to be reconciled with traditional religious symbolism. Along with the proliferation of botanical literature, which enabled artists to expand their knowledge of plants, identities, and habits, the development of the magnifying glass intensified their visual understanding of floral form. By the mid-16th century, the magnifying glass was in fairly common use, and not long after, the combined microscope. The effect of these developments on the increased naturalism of floral detail is undeniable. Such 19th-century artists as Severin Roesen, who carried on the earlier still-life tradi-

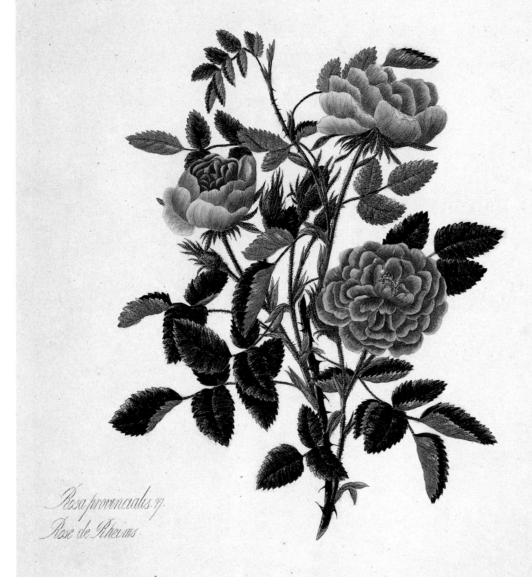

Rosa provincialis η.
Rose de Rheims.

Published by Mary Lawrence Teacher of Botanical Drawing No 86 Queen Ann Street East August 1798.

Mary Lawrence del et sculp.

Mary Lawrence
English, 1790–1831
Rose Provicialis / Rose de Rheims
from a collection of *Roses from Nature,* London, 1799
Etching and stipple engraving, handcolored
12⅞ x 11 inches
Bequest of the Estate of George P. Dike,
Elita R. Dike Collection. 69.240

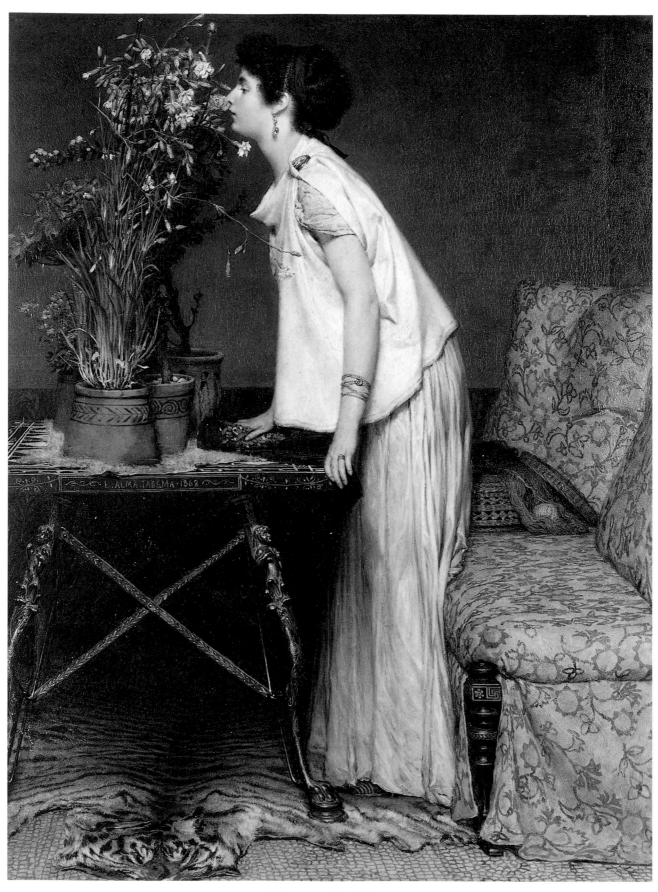

Sir Lawrence Alma-Tadema
Dutch (worked in England), 1836–1912
Woman and Flowers (Opus LIX)
Oil on panel, 19⅜ x 14⅜ inches
Gift of Edward Jackson Holmes. 41.117

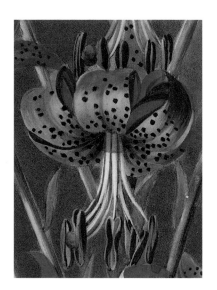

tion, inherited the scientific precision as well as the symbolic overtones of the earlier painters. We can only wonder whether Roesen or his public was aware of the rich combination of science and spirit implicit in the images.

The 19th-century preoccupation with nature in Europe and in America spawned a variety of new floral images to complement the burgeoning genre of landscape art. In the *Temple of Flora,* published in England by Robert Thornton, elaborate engravings showed botanical specimens in landscape settings, instead of on a neutral ground, to enhance the expression of organic life. Responding to the revolutionary botanical theory of the Swedish botanist Carl Linnaeus, Thornton's flowers were represented at various stages of bloom and the reproductive parts were dramatized to clarify their place within the Linnaean sexual system of plant classification. Although his flowers are presented in more modest surroundings, Jean-Pierre Redouté immortalized the rose in his exquisite stipple-colored prints, entitled *Les Roses,* issued in three volumes from 1817 to 1824. While

documenting the enormous variety of rose species, these images also convey their distinctive character—some robust and flamboyant, others fragile and delicate. One can even imagine their scents from these vivid renderings. The ancients had recognized the rose as the queen of flowers and associated it with beauty and love. According to Greek mythology, as Venus ran to help her beloved Adonis, she tripped on a thorn and stained all the white roses in her path red from her blood. Floral dictionaries, flower painting instruction books, greeting cards, and flower gift books of the 19th century confirm the continued popularity of the rose and its symbolic association with love. Gardening manuals and seed catalogues attest to the preeminence of roses in 19th-century gardens as well.

Severin Roesen, William Sharp, Martin Johnson Heade, Henri Fantin-Latour, Pierre Auguste Renoir, and John La Farge were only a few of the 19th-century artists who succumbed to the allure of the rose. Most often, the cultivated hybrid is represented in combination with

other ornamental garden flowers in a rich bouquet that is embraced by a vase of elaborate design. More rarely, the wild rose is shown growing in an informal outdoor setting. Whatever the context, these artists acknowledged the important history of the rose in the literature, science, gardens, religion, and imagination of the West. It held no such appeal in the Far East. On a drive through the countryside in Japan, La Farge caught the scent of some wild roses, which immediately reminded him of home. He remarked that the Japanese neither cared for the rose nor understood it. "With them the rose has no records, no associations, as with us," he said. "On this farther side of the garden of Iran, the peony and the chrysanthemum, the lotus and the iris, the peach, the cherry and the plum, make up the flower poetry of the extreme East."[5] By the later 19th century, these exotic oriental flowers had become fashionable in western gardens and western paintings. The four noble plants of the Ming dynasty—the bamboo, the plum, the orchid, and the chrysanthemum—as well as the azalea appealed

to artists because of their association with eastern culture and its long and revered tradition of nature painting and philosophy.

The wildflower, recognized earlier by Albrecht Dürer for its delicacy and beauty, developed a passionate following among those who promoted the importance of capturing the "truth of nature." John Ruskin, the 19th-century British critic and artist, encouraged painters to approach nature in a spirit of humility and with an open heart. With such a freedom of spirit the artist or the gardener could explore the inherent aesthetic order of nature in its pristine form. He advised the growers and painters of flowers, for moral reasons, to avoid the hybrids or the "florist's flowers" that had been the glory of the Dutch tradition. "A flower-garden is an ugly thing, even when best managed," he warned. "It is an assemblage of unfortunate beings, pampered and bloated above their natural size, stewed and heated into diseased growth; corrupted by evil communication into speckled and inharmonious colours; torn from the soil which they loved, and of

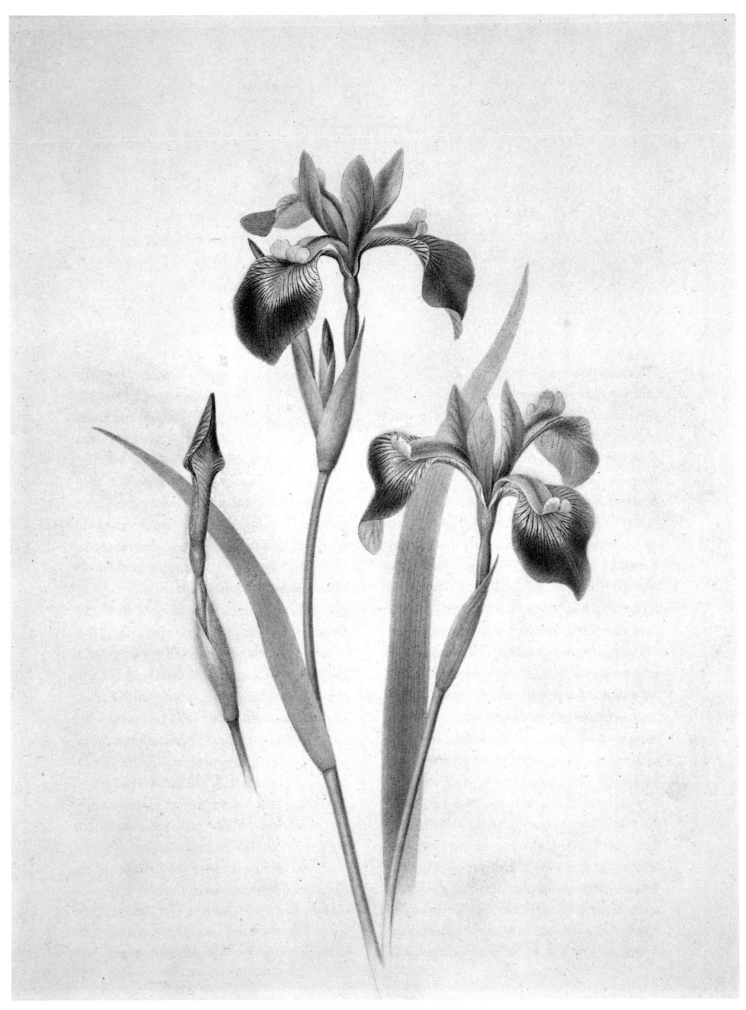

Isaac Sprague
American, 1811–1895
Iris
Watercolor, 14½ x 10¾ inches
Bequest of Miss Priscilla C. Sprague. 1977.227

devoted to this garden at Appledore were published as illustrations to Thaxter's last book entitled *An Island Garden,* published in 1894. The freshness of Hassam's paintings of flowers bending in the wind conveys the wonder that he shared with Thaxter at the miracle of plant growth. "Of all the wonderful things in the wonderful universe of God," wrote Thaxter at the opening of *An Island Garden,* "nothing seems to me more surprising than the planting of a seed in the blank earth and the result thereof."[9]

A pupil of John La Farge, the flower painter Maria Oakey Dewing wrote an article in 1915 entitled "Flower Painters and What the Flower Offers to Art." In her consideration of works from many different cultures and periods, she remarked upon the inaccuracies of Dutch flower painting of the preceding centuries. She objected to the Dutch practice of combining flowers that had no relationship to each other. "They are grouped with no idea of truth to nature," wrote Dewing with disapproval; "the tulip is placed in a bouquet with a passion flower—the hot-house and the spring garden mixed."[10] A truly naturalistic depiction of flowers, in Dewing's view, depended upon loyalty to relationships that could be found in nature. Ruskin and, in a different context, Darwin also emphasized the importance of capturing the flower's manner of growth and integrating it into an appropriate physical environment. Dewing was an avid gardener herself, and she contended that "if one would realize the powerful appeal that flowers make to art let them bind themselves to a long apprenticeship in the garden. Who without long acquaintance, can tell the color of a bed of auratum lilies? The long buds, with no calyx, growing right out of the stalk, faintly tinged with the same green, designed with an elegance fit for sculpture, merely clinging together, the long petals form the bud."[11]

Charles Demuth, like Dewing, developed his attraction to flower painting by "a long apprenticeship in the garden." Most of his floral subjects were taken from just outside the door of his studio in Lancaster, Pennsylvania, which overlooked a Victorian garden developed by his mother. In

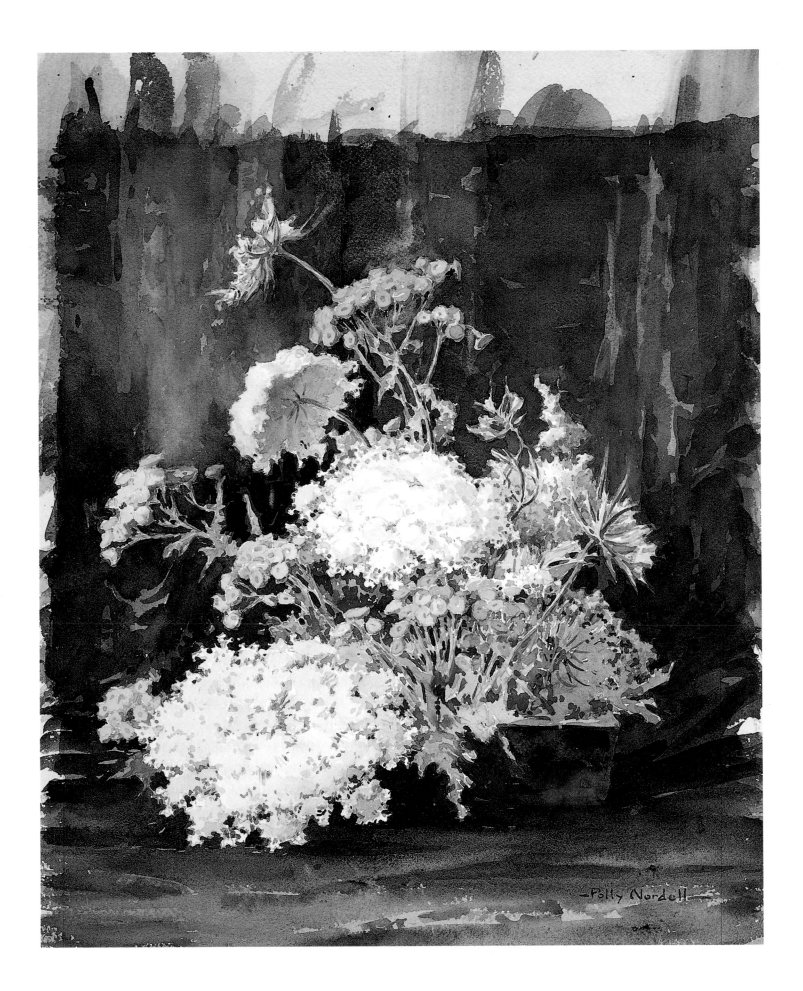

Polly Nordell (Emma Parker Nordell)
American, 20th Century
Wildflowers
Watercolor, 20⅜ x 14¾ inches
Gift of Eunice E. Huntsman. 1981.60

ment has paradoxically made the understanding of the world around us more inaccessible. A descriptive analysis of nature will not render profound insights into its essential workings. These are to be found on such a grand or tiny scale, in black holes or DNA molecules, that they are barely accessible to the trained specialist. O'Keeffe and other 20th-century artists have continued to seek out flowers as potential keys to understanding a natural universe whose dimensions escape our grasp. Flowers, as microcosms of the organic world, embraced explainable truths, if only we could look at them properly and, thereby, grasp what they mean. "In a way—nobody sees a flower—really," said O'Keeffe. So she blew the flower up to a size large enough to achieve the central goal of her art. Through her paintings of flowers, O'Keeffe, like many painters before her, aimed to give form to "the inexplainable thing in nature that makes me feel the world is big far beyond my understanding."[14]

[1] The Works of Alfred Lord Tennyson, annotated by Alfred Lord Tennyson, edited by Hallam Lord Tennyson (New York, 1970), Vol. 2, p. 293. (Reprinted from the London, 1907–8 edition.)

[2] Leonardo da Vinci, *Treatise on Painting [Codex Urbinas Latinas 1270]*, translated by A. Philip McMahon (Princeton, N.J., 1956), Vol. 1, p. 293.

[3] Leonardo, *Treatise on Painting*, p. 41.

[4] Wilfrid Blunt, *Tulipomania* (Harmondsworth, Middlesex, U.K.: Penguin Books, 1950), p. 15.

[5] John La Farge, *An Artist's Letters from Japan* (New York, 1897), p. 41.

[6] John Ruskin, "The British Villa," in *The Complete Works of John Ruskin,* edited by E. T. Cook and Alexander Wedderburn (London: George Allen; New York: Longmans, Green & Co., 1903–12), Vol. 1, p. 156.

[7] "Art as Record," *The New Path,* August, 1863, p. 43.

[8] Charles Darwin, *On the Origin of Species by Means of Natural Selection; or The Preservation of Favoured Races in the Struggle for Life,* rev. ed. (New York, 1860), pp. 423–24.

[9] Celia Thaxter, *An Island Garden* (Boston and New York: Houghton, Mifflin & Co., 1894), p. 3.

[10] Maria Oakey Dewing, "Flower Painters and What the Flower Offers to Art," *American Magazine of Art: Art and Progress,* Vol. 6 (June 1915), p. 262.

[11] *Ibid.*

[12] Henry McBride, "Demuth," in *The Flow of Art: Essays and Criticisms of Henry McBride,* edited by Daniel Catton Rich (New York, 1975), p. 218.

[13] Charles Sheeler, paper read at a symposium on photography, The Museum of Modern Art, New York, October 20, 1950, published as part of his "The Black Book," in *Charles Sheeler* exhibition catalogue (Washington, D.C., 1976), text facing p. 100.

[14] *Georgia O'Keeffe* (New York: Viking Press, 1976), text facing figs. 23 and 100 [unpaginated].

For more on the floral details seen here: p. 8–see plate 3; p. 10–see plate 10; p. 11–see plate 24; p. 12–see plate 4; p. 15–see plate 2; p. 16–see plate 8; p. 18–see plate 7; p. 19–see plate 9; pp. 20, 22–see plate 26; p. 23–see plate 22; p. 24–see plate 20; p. 25–see plate 6; p. 80–see plate 19.

THE
PLATES

1

JAN VAN HUYSUM

DUTCH, 1682–1749

Vase of Flowers in a Niche
Oil on panel, 35 x 27½ inches
Bequest of Stanton Blake. 89.503

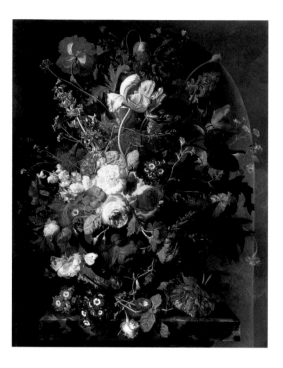

The son of the Dutch flower painter Justus van Huysum the Elder, Jan van Huysum inherited the distinguished 17th-century tradition of still-life painting and then impressed it with his own mark. This elaborate bouquet of blossoms that come into flower at different times of the year is barely contained in a vase decorated with bas-relief cupids standing on a marble tabletop. Although framed by a niche, the full-blown specimens of tulips, roses, primula, fritillaria, and morning glories seem to bend and swell in an effort to burst free from the confinement of their surroundings.

The vitality of this floral image emerges from the method of van Huysum. He insisted upon working from live specimens. Paintings such as this one often required one or two years to complete while the artist waited for the blossoms he wished to include to come into season. Therefore, van Huysum did not arrange a group of flowers and then paint from the model; rather, he composed an artificial assemblage of flowers treated with exquisite botanical accuracy.

Van Huysum's work was very popular in his own day and this exuberant bouquet shows why. The fine graphic technique, the attention to the varieties of textural qualities, and the resonant color of this flowerpiece are combined to produce a masterpiece of the genre. The work of this 18th-century master flower painter continued to be appreciated in 19th-century America. A writer for the *Illustrated Magazine of Art* (1854) considered van Huysum the model Dutch flower painter who "seeks to rouse sympathy and admiration in the heart of the amateur of gardens, to awaken in his soul the emotions naturally suggested and kindled in the mind of one who loves flowers, who knows their history, their family, their varieties, and their perfume."

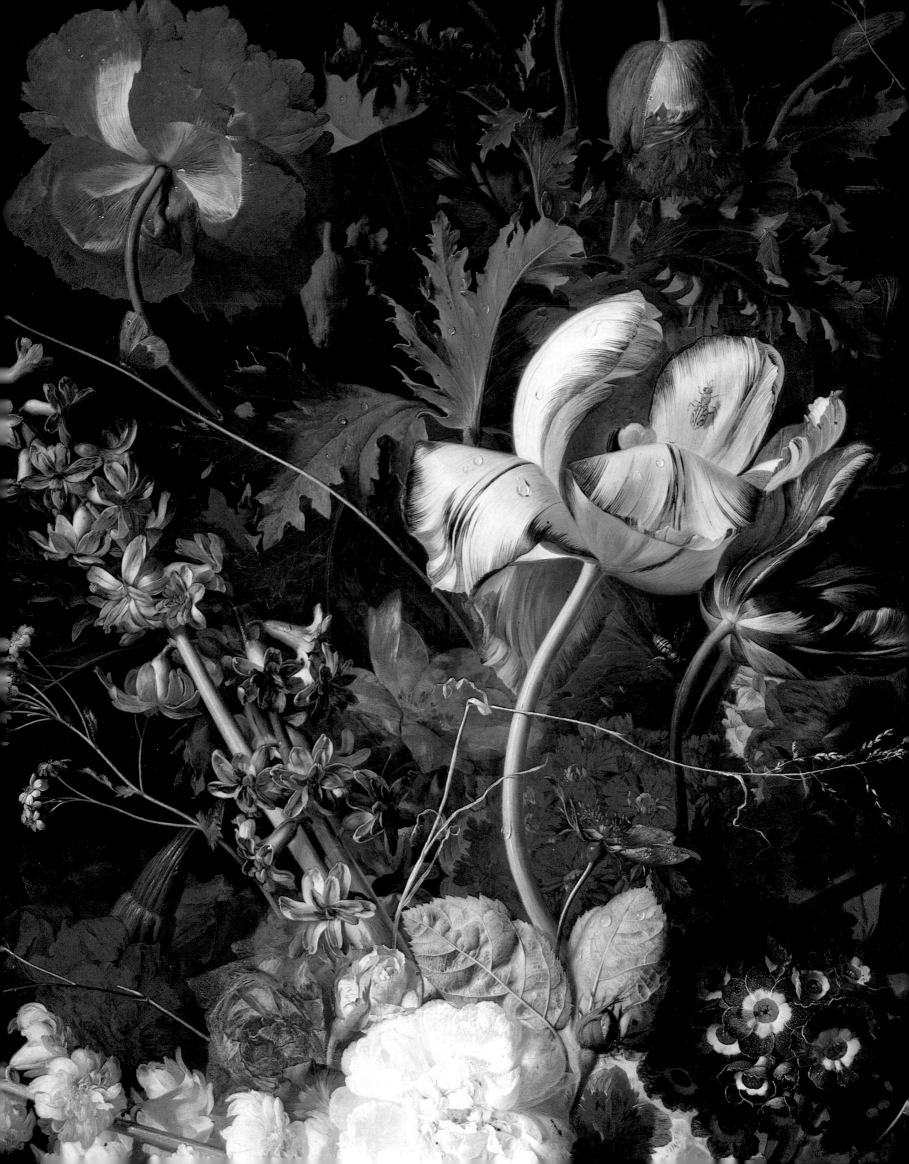

RICHARD EARLOM

ENGLISH, 1742/3–1822
AFTER PHILIPP REINAGLE, ENGLISH, 1749–1833

The Superb Lily, 1799
(from *The Temple of Flora*)
Color mezzotint and aquatint, with hand coloring
14⅛ x 18⅞ inches
Elita R. Dike Collection, Bequest of the Estate of George P. Dike. 69.312

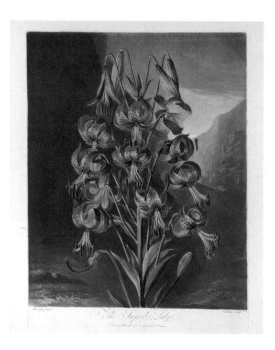

The Superb Lily is one of a series of large color prints conceived and published by Dr. Robert John Thornton, a lecturer on medical botany at Guy's Hospital in London. The grand folio, produced at the turn of the 18th century, was entitled *The Temple of Flora* or *New Illustrations of the Sexual System of Linnaeus*. It was an elaborate and costly venture. Thornton engaged the most distinguished botanical artists of his day to make the original paintings (in this case Philipp Reinagle). To reproduce them in mezzotint and aquatint engravings required the collaboration of such highly proficient printers as Richard Earlom.

Both the size and the composition of these color plates were unique. They presented large-scale close-ups of flowers growing in a landscape setting rather than the cut specimens on a blank page that were the staple of botanical prints. The orange and gold lily looms dramatically large and brilliant against the background mountain landscape. Although the set-ting does not necessarily provide an appropriate natural habitat for the lily, it does enhance its organic qualities. Indeed, the stage-like setting casts the plant in a leading role on the stage of nature designed by the Swedish botanist Carl Linnaeus, whose sexual system of plant identification revolutionized the study of botany and engendered such new modes of flower illustration as this.

Unfortunately, Dr. Thornton's work was never completed. He had intended to illustrate "every class by select examples of the most interesting flowers, accurately described, and immortalized by poetry."[1] Of a projected seventy plates, only thirty were accomplished, but they would influence the course of botanical illustration and flower painting throughout the 19th century.

[1]Gordon Dunthorne, *Flower and Fruit Prints of the 18th and Early 19th Centuries* (New York: Da Capo Press, 1970), p. 38.

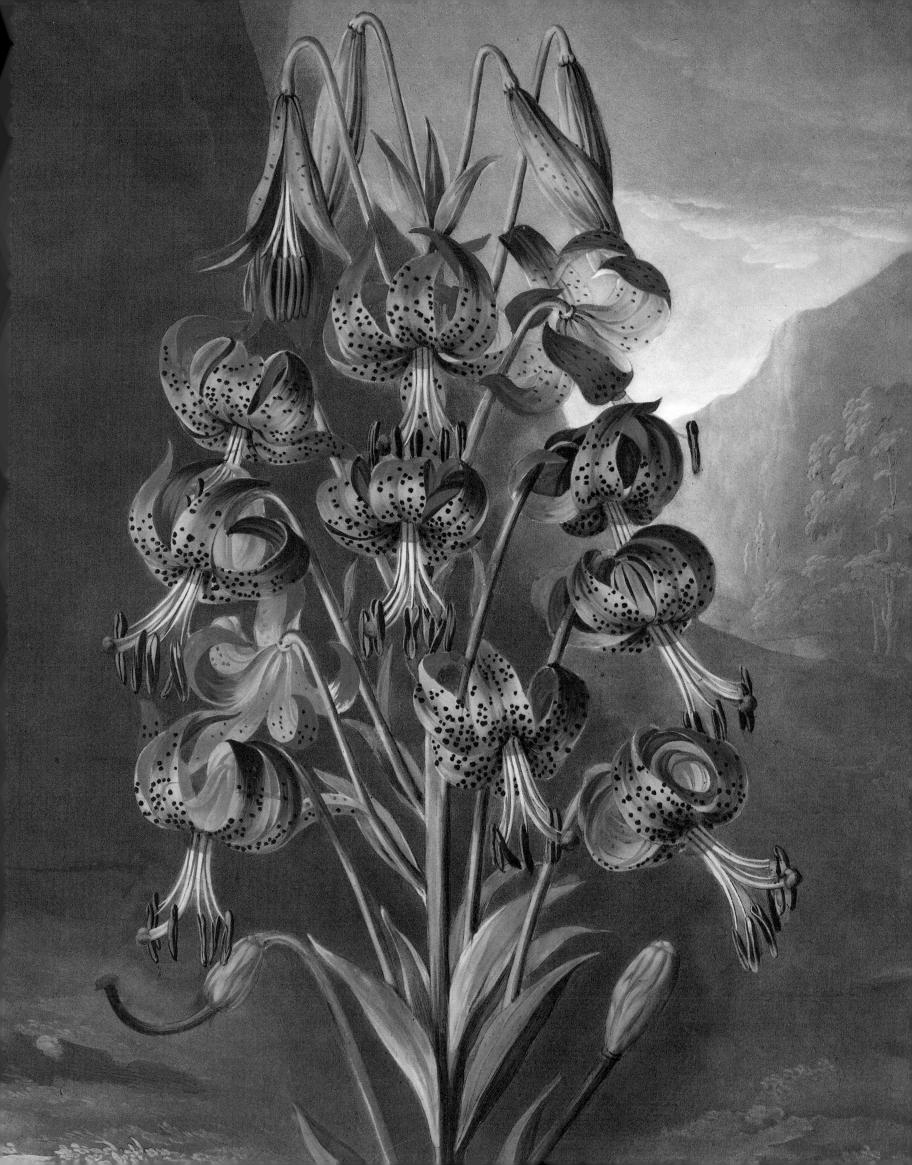

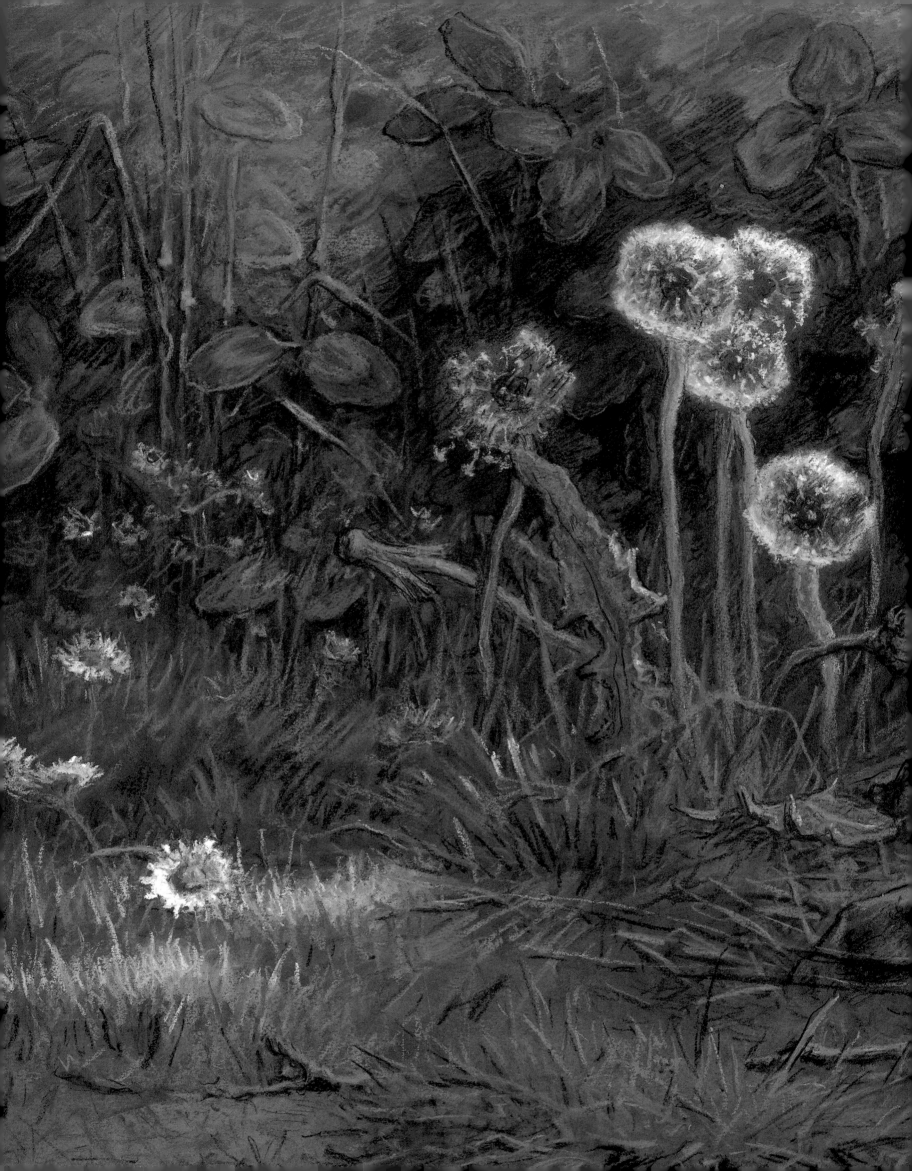

3

Jean François Millet

French, 1814–1875

Dandelions
Pastel on paper, 15⅞ x 19¾ inches
Gift of Quincy Adams Shaw through Quincy A. Shaw, Jr.
and Mrs. Marian Shaw Haughton. 17.1524

Born near Cherbourg, Jean François Millet was awarded a scholarship to study in the Paris studio of the French history painter Paul Delaroche. Perhaps it was this training that led him to concentrate on figure subjects. A cholera epidemic of 1849 forced Millet and his wife to move from Paris to a small cottage in Barbizon where he spent the rest of his life. There he selected his figures from the local peasant population and painted heroic images of them and their work. These idealized compositions depicted sowers and gleaners and glorified their relationship with the land in very general terms.

By contrast, this pastel close-up of dandelions, daisies, rocks, and fallen twigs in a grassy setting is a realistic and detailed transcription of nature. Aside from centering the dandelion seed heads, the image seems uncomposed. Perhaps this is a sketch, albeit treated in finished detail, that served Millet as a model for a foreground element in a large-scale oil landscape composition. Although, in most cases, Millet avoided working directly from nature as a method of painting, the *Dandelions* indicates that he could produce lifelike and delicate images when he chose to do so.

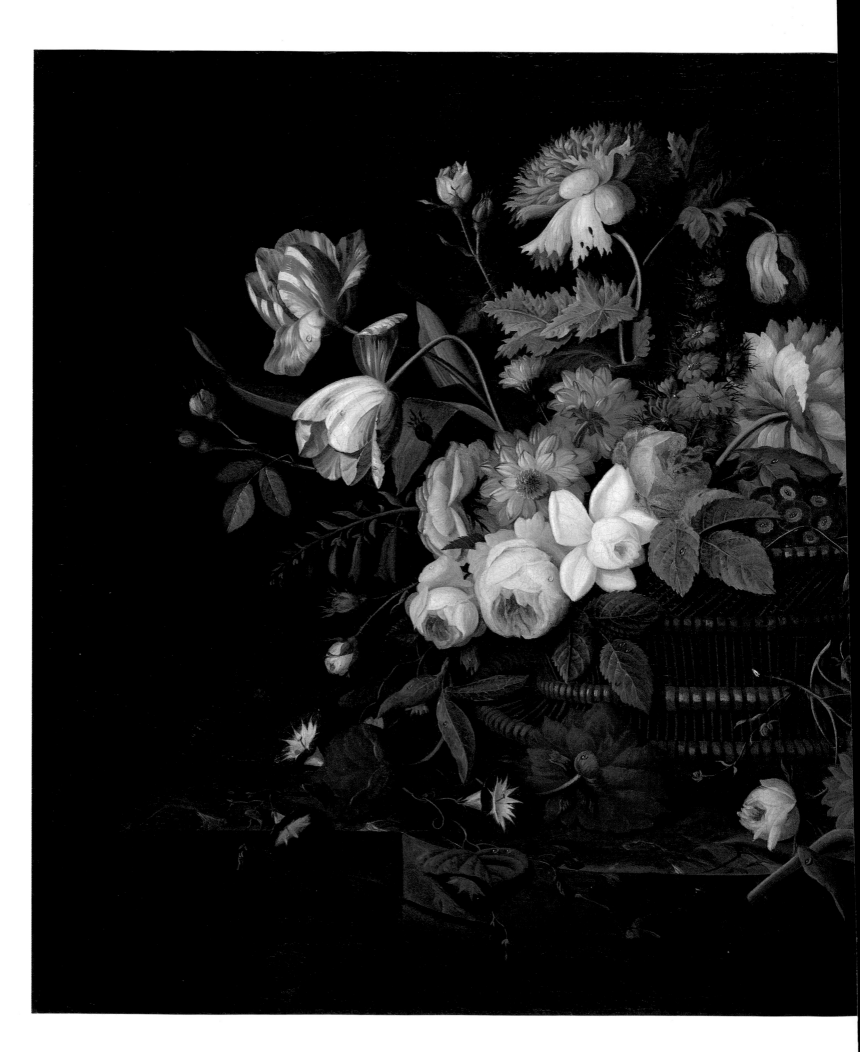

4

SEVERIN ROESEN

AMERICAN, BORN GERMAN, ?–1871

Still Life — Flowers in a Basket
Oil on canvas, 30 x 40¼ inches
Purchased M. and M. Karolik Fund. 69.1228

When Severin Roesen emigrated to America in 1848 from Cologne, Germany, he brought with him the tradition of Dutch 17th-century flower painting and his early training as a porcelain painter. He specialized exclusively in still-life painting, including fruit and flowers, and he worked in New York City and Williamsport, Pennsylvania. The selection of full-blown cultivated blossoms, especially the striped tulips, the roses, and the dahlias, indicates that Roesen adopted the bouquets of such earlier flower painters as Ambrosius Bosschaert, Jan van Huysum, and Rachel Ruysch. He embellished this inherited tradition with his own bright-hued palette and sharp precision of detail. Clearly, the enamel-like surface of the painting and the graphic intensity of every shape developed from Roesen's exacting training in the decoration of porcelain. The work of Severin Roesen was not well known in his day, but as his productions have been gathered and documented in recent years the calibre of his achievement in flower painting has received the appreciation it deserves.

MARTIN JOHNSON HEADE

AMERICAN, 1819–1904

Vase of Mixed Flowers
Oil on canvas, 17¼ x 13¾ inches
Bequest of Martha C. Karolik for the Karolik Collection of
American Paintings, 1815–1865. 48.427

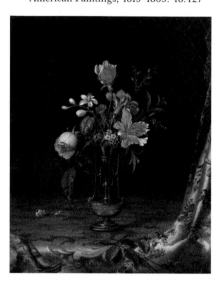

This delicate rendering of a *Vase of Mixed Flowers* represents one of a number of modes of still-life painting, almost always flowers rather than fruit, that Martin Johnson Heade painted throughout his life. Although Heade painted some portraits early in his career, it was landscape and flowers that dominated his artistic oeuvre.

Born in Lumberville, Pennsylvania, in 1819, Heade traveled widely. In 1863–64, he was in Brazil with the naturalist Reverend J. C. Fletcher on a mission to record, paint, and eventually publish an illustrated book documenting the hummingbirds of South America. Although the project was never realized, Heade discovered a world of exotic flowers such as orchids, passionflowers, and waterlilies that, along with hummingbirds, would populate his paintings. However, the *Vase of Mixed Flowers*, painted c. 1865–75, indicates that Heade did not shift his floral repertory to tropical flowers exclusively after his return from South America. The pastel bouquet includes a rose, hibiscus, heliotrope, orange blossom, carnation, and heather, all of which were common garden flowers in mid-19th-century America. The floral arrangement is supported by a finely wrought, gilt, French vase set in an elaborately patterned interior. Its "Victorian" quality is conveyed by the rich but somber color of the setting and the subtle attention to surface texture and patterning. However, the restrained treatment of the wallpaper design and the brocade draperies prevents them from distracting our attention from the floral bouquet that the artist offers for our contemplation. Each flower is treated as a separate but equal member of a stringed ensemble. Its shape, its color, its stem, its leaves, its stage of bloom, all have their separate voices. Together they produce a visual score that expresses a beauty of decorative arrangement and meaning. There is a religious, almost sacramental, quality to this bouquet that compares to a description of a vase of flowers found on the communion table of a New England church by the art critic Henry Tuckerman. "The sight of this vase of flowers," he wrote, "was like an enchantment. It spoke of nature, of beauty, of truth, more eloquently than the service."[1]

[1] Henry T. Tuckerman, "Flowers," *Godey's Lady's Book*, Vol. 40 (January 1850), p. 13.

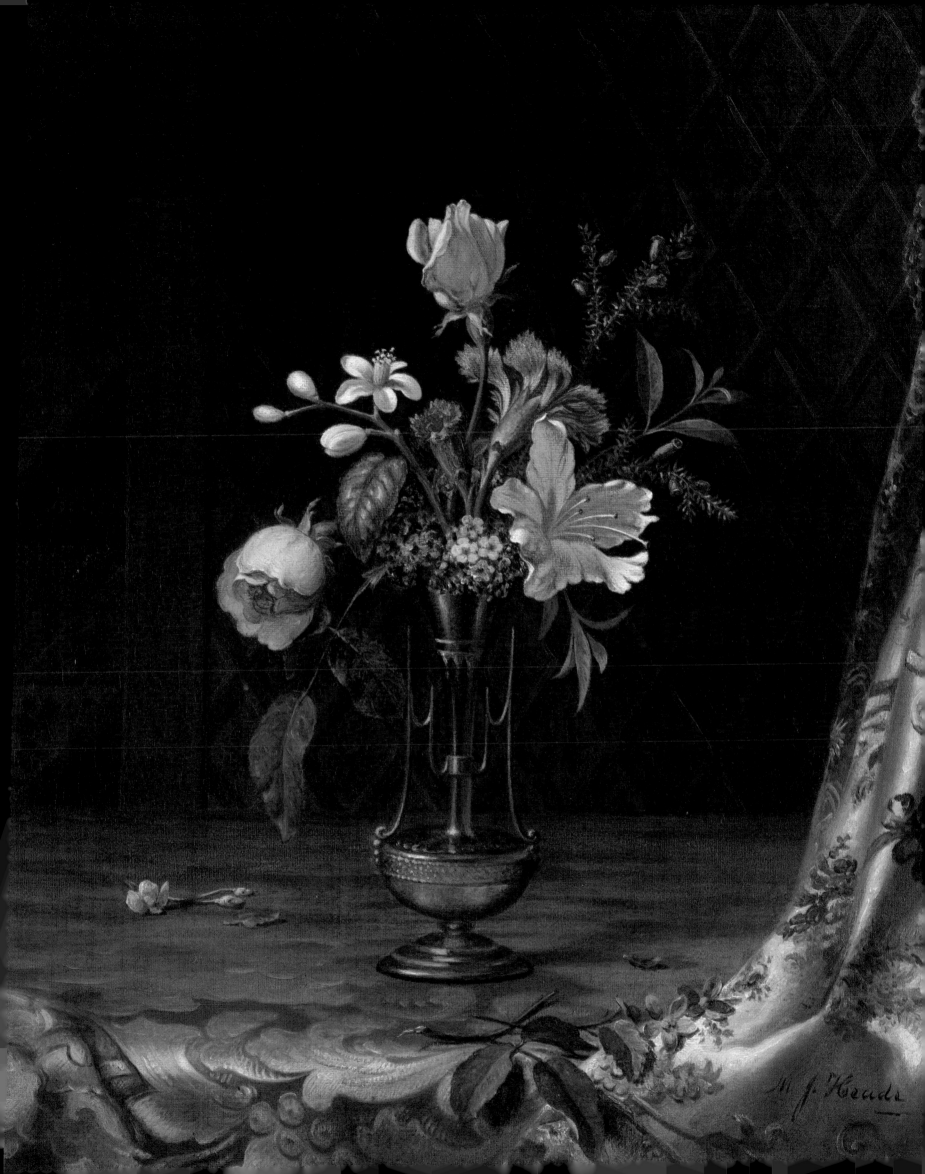

WILLIAM SHARP

AMERICAN, ACTIVE 1819?–1862

Fruit and Flower Piece, 1848
Oil on canvas, 36 x 29 inches
Bequest of Maxim Karolik. 64.449

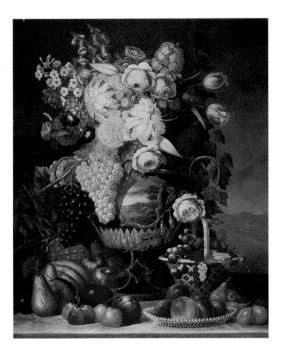

Born in England, William Sharp worked in London as a lithographer before he came to America in 1838 and settled in Boston, where his principal occupation was also lithography. Credited as one of the first to experiment with color in that print medium, he is best known for his illustrations of fruit and flowers published in the *Fruits of America* which appeared from 1847 to 1852.

This abundant display of roses, lilies, tulips, dahlias, foxglove and morning glories is gathered in a gilded French porcelain vase which stands on a tabletop where luscious varieties of fruit compete for attention. Like the cultivated floral specimens, the fruits are both local and exotic in type and their containers were made in different parts of the world. The fruits and flowers, in their ripe perfection, are enveloped in pressed glass, painted porcelain and woven straw. The rich variety of material, color and shape make the painting a symbolic tribute to the boundless possibilities of nature and art.

7

PAUL GUSTAVE LOUIS CHRISTOPHE DORÉ

FRENCH, 1832–1883

Summer
Oil on canvas, 104⅞ x 78¾ inches
Gift of Richard Baker. 73.8

A native of Strasbourg, Paul Gustave Doré established his reputation as a prolific and successful book illustrator. It was his drawings for Rabelais and for Balzac's *Contes Drolatiques* (1854–55) that gained him his initial reknown. His large-format original prints for books anticipate modern artbooks on which illustrious writers and artists collaborate.

Later in life, Doré indulged in his long-standing ambition to be a painter and sculptor rather than a book illustrator. Some of the intensity of his early graphic training emerges in this floral evocation of *Summer.* The close-up view of a field of wild flowers including daisies and Queen Anne's lace blossoming among summer grasses provides a sharp focus on the foreground details. Using a fine brush with the precision of a pencil, Doré inscribes the delicate contours of leaves, stems, and petals. He invites us to share the wonder of his own contemplation of these humble but beautiful specimens of the botanical kingdom. Yet clearly plant identification is not his artistic bent. A group of butterflies taking to the air leads our eyes to a distant castle crowning a hill and emerging from the mist. The artist suggests some kind of narrative—perhaps a mystical relationship between the floral foreground and architectural background—but leaves the interpretation to us.

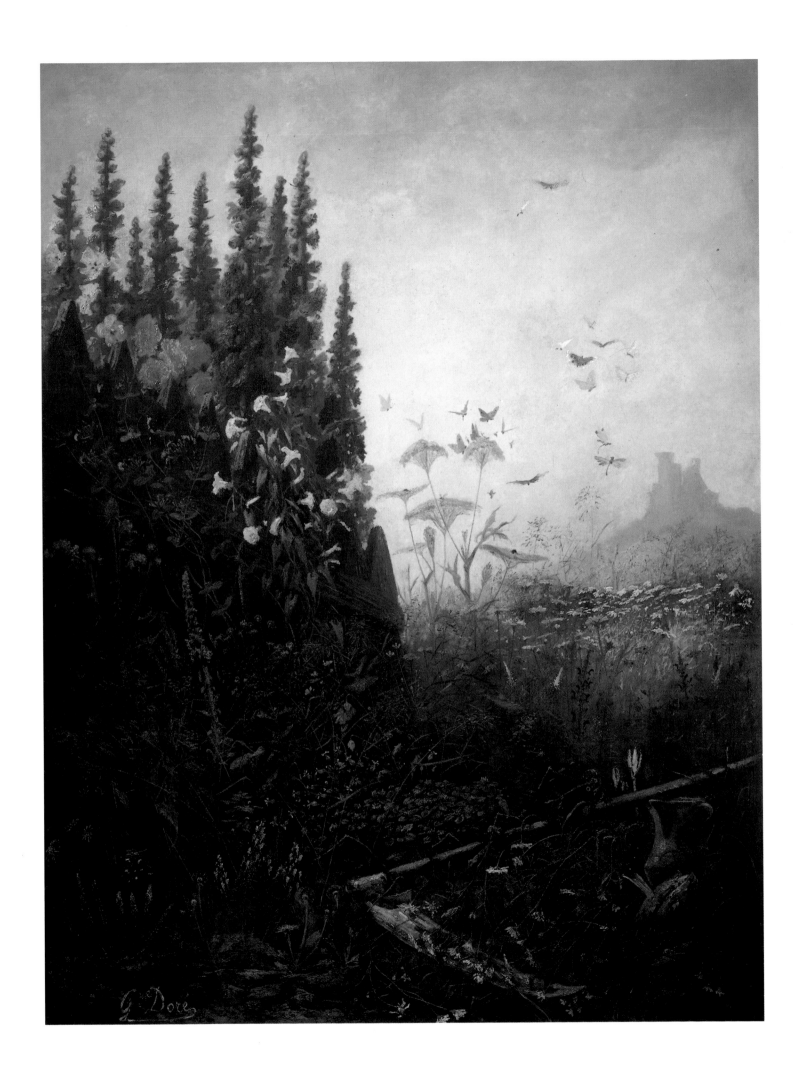

8

JOHN LA FARGE

AMERICAN, 1835–1910

Vase of Flowers
Oil on panel, 18½ x 14 inches
Gift of Louise W. and Marian R. Case. 20.1873

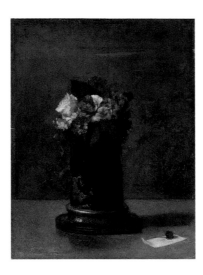

Signed and dated 1864 on the small piece of paper resting on the tabletop, this evocative *Vase of Flowers* by John La Farge is an early work by the New York born artist who would later devote his attention to mural painting and to the design of stained glass. Like the landscapes produced during the 1860s, this image combines a simplification of form and color with a loose and suggestive brushwork. La Farge does not want us to examine this bouquet for its botanical accuracy but rather for its power to call up associations. He appreciated flowers not so much for their formal beauty as for their symbolic value. Waterlilies, for example, for La Farge "always appealed to the sense of something of a meaning—a mysterious appeal such as comes to us from certain arrangements of notes of music."[1]

Although John La Farge did not travel to Japan until 1886, his taste for Japanese art and style was developed much earlier. He admired the technical proficiency in the treatment of lacquer, ivory, porcelain, and enamel, but most of all it was the subtle and novel arrangement of form that constituted the grandeur of Japanese art for La Farge. "Japanese composition in ornamental design has developed a principle which separates it technically from all other schools of decoration. This will have been noticed by all who have seen Japanese ornamental work, and might be called a principle of irregularity, or apparent chance arrangement: a balancing of equal gravities, not of equal surfaces. . . .Thus a few ornaments—a bird, a flower—on one side of the page would be made by an almost intellectual influence to balance the large unadorned space remaining."[2]

In the *Vase of Flowers*, the power of the empty space is tangible. The subtle off-center placement of the vase allows its shadow and the barely visible pattern of the wallpaper on the right to do more than just fill a void. La Farge conveys a mystery with this small bouquet, and he is not interested in solving it for us.

[1]Royal Cortissoz, *John La Farge A Memoir and a Study* (Boston and New York: Houghton Mifflin Company, 1911), p. 136.

[2]John La Farge, "An Essay on Japanese Art," in Raphael Pumpelly, *Across America and Asia* (New York: Leypoldt & Holt, 1870), p. 197.

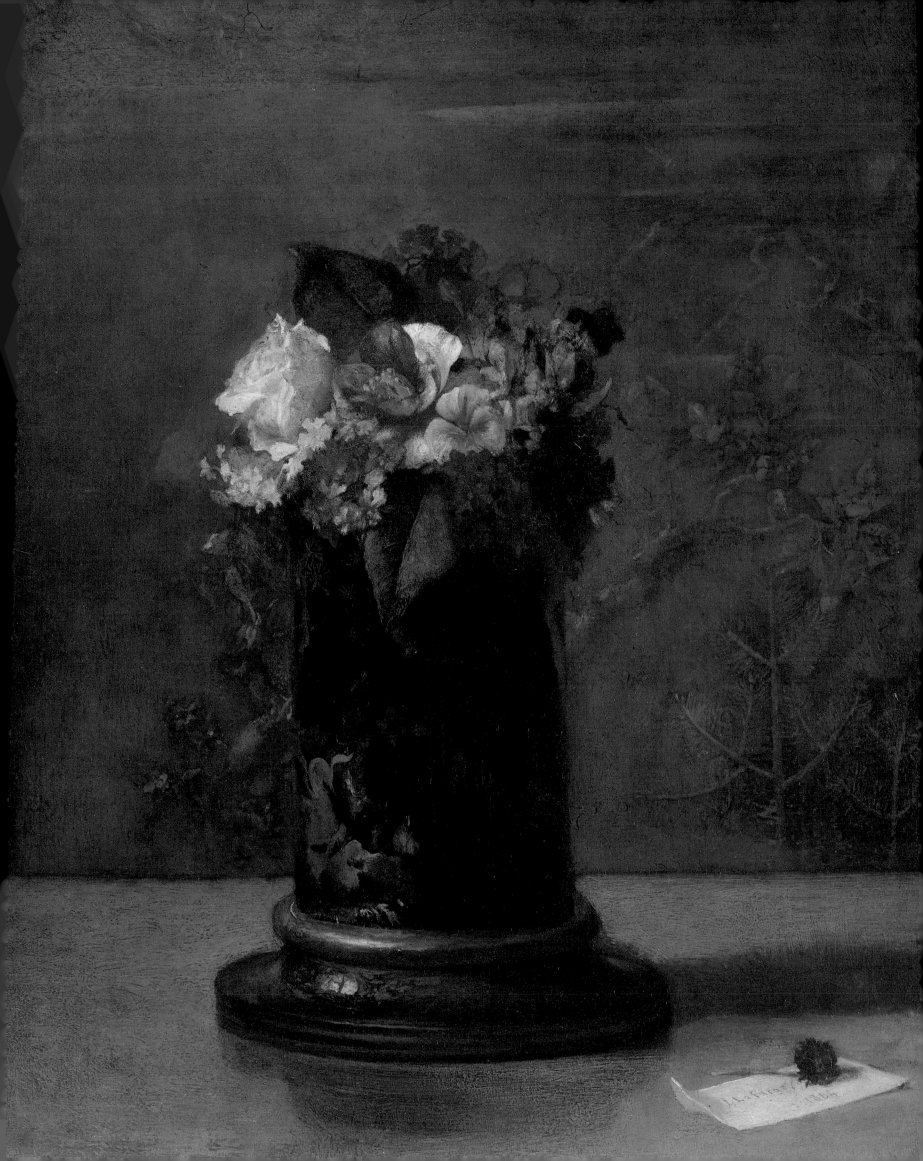

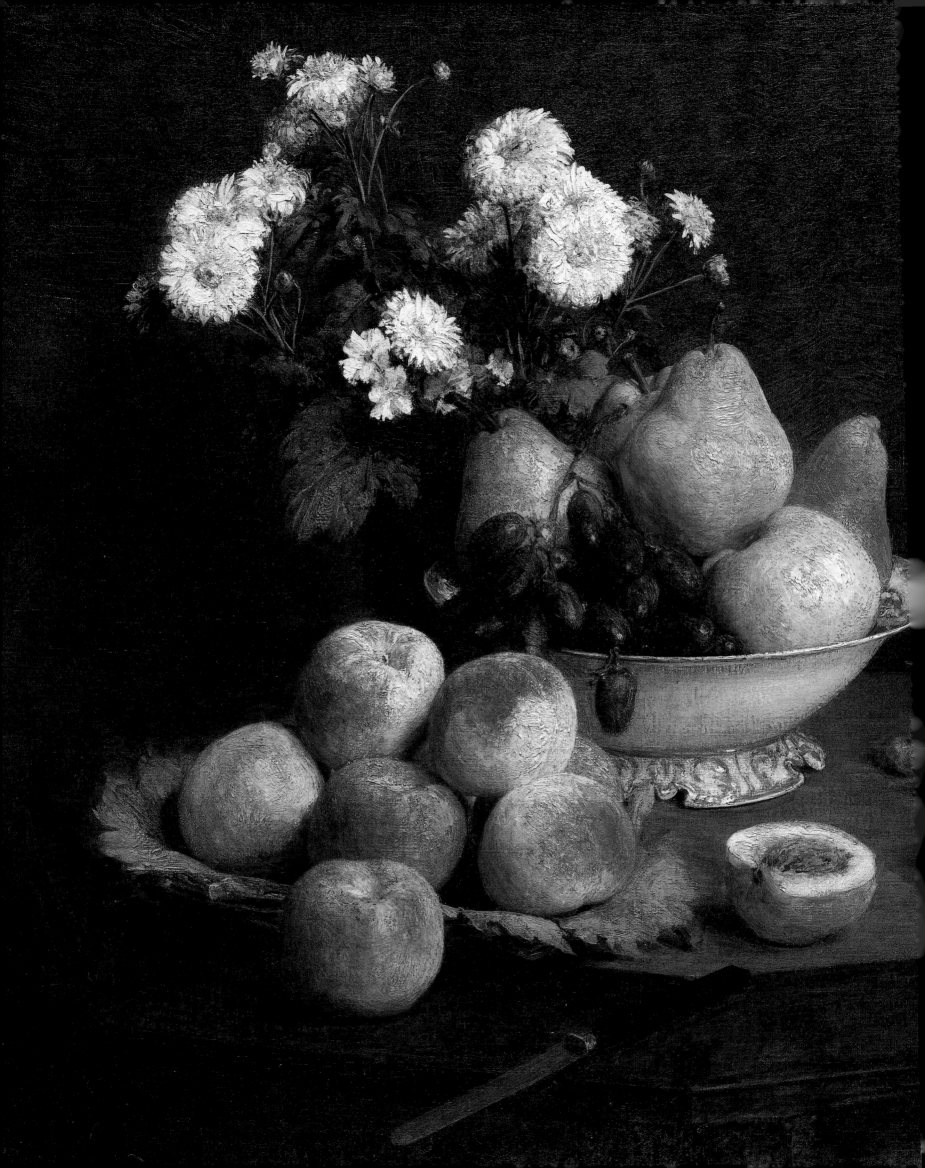

IGNACE HENRI JEAN THÉODORE FANTIN-LATOUR

FRENCH, 1836–1904

Flowers and Fruit on a Table
Oil on canvas, 23⅝ x 28⅞ inches
Bequest of John T. Spaulding. 48.540

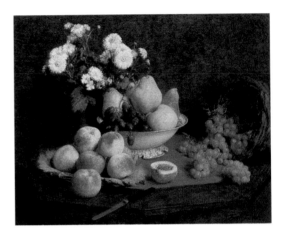

Although Henri Fantin-Latour painted individual and group portraits as well as mythological subjects, he gained his reputation as an artist through the depiction of flowers and still-life subjects. He spent his winters in Paris as an active participant in the vital artistic life of the city, but in June he escaped to a cottage in Normandy, where he found the subjects for his painting in the garden just outside his door. It is not surprising that the greatest admirers of Fantin-Latour's flower paintings were found across the Channel in England—a country devoted to gardening.

This simple arrangement of summer fruits and a bouquet of chrysanthemums recalls the kitchen still lifes of his renowned French predecessor Jean-Baptiste-Siméon Chardin more than the elaborate ones of such Dutch painters as Jan van Huysum. The muted tones of the fruits and flowers carefully arranged on a plain tabletop and set against a neutral background compare in their restraint to the sounds of a string quartet. The more flamboyant side of Fantin-Latour's taste found expression in his devotion to the bombastic orchestral works of the German composer Richard Wagner.

10

ODILON REDON

FRENCH, 1840–1916

Large Green Vase with Mixed Flowers
Pastel on paper, 29¼ x 24½ inches
Bequest of John T. Spaulding. 48.591

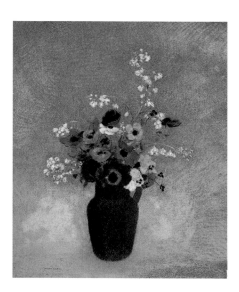

Odilon Redon was a contemporary of the Impressionist painters Claude Monet and Pierre Auguste Renoir, but his artistic sensibility anticipated the younger generation of Symbolist writers and artists. For him, art emphasized the role of imagination over description of the visible world. "Some people insist upon the restriction of the painter's work to the reproduction of what he sees," wrote Redon with disdain. "Those who remain within these narrow limits commit themselves to an inferior goal. The old masters have proved that the artist, once he has established his own idiom, once he has taken from nature the necessary means of expression, is free, legitimately free, to borrow his subjects from history, from the poets, from his own imagination."[1] His early drawings and lithographic albums resisted the naturalistic current of his day with images of marsh plants coming into flower with radiant human heads, skeletons emerging gracefully out of amorphous settings, and enlarged eyes capping long tubular stems.

However, throughout his life Redon scrutinized nature and sketched its details with scrupulous accuracy. In his later flower paintings such as this

Large Green Vase with Mixed Flowers, painted about 1910, his assimilation of the look and feel of these delicate blossoms of red, pink, yellow, and blue anemones interspersed with sprays of coral bells and clusters of dried berries is apparent. Set against a plain background enlivened by subtle strokes of neutral shades, this bouquet seems to float in an elusive space. The evanescent pastel blossoms, although rooted in Redon's careful observation of nature, have been transformed into a poetic vision by the artist's irresistible urge to create something imaginary.

Gauguin, a great admirer of Redon, recognized the special genius of the visions of his inner eye. He wrote that Redon's "dreams become reality through the probability he gives them. All his plants, his embryonic beings are essentially human, have lived with us; they certainly have their share of suffering."[2] There is a poignant vulnerability in this gentle floral grouping that suggests its inherent inevitable decay.

[1]John Rewald, *Post-Impressionism: From Van Gogh to Gauguin* (New York: The Museum of Modern Art, 1962), p. 169.

[2]*Ibid.*, p. 454.

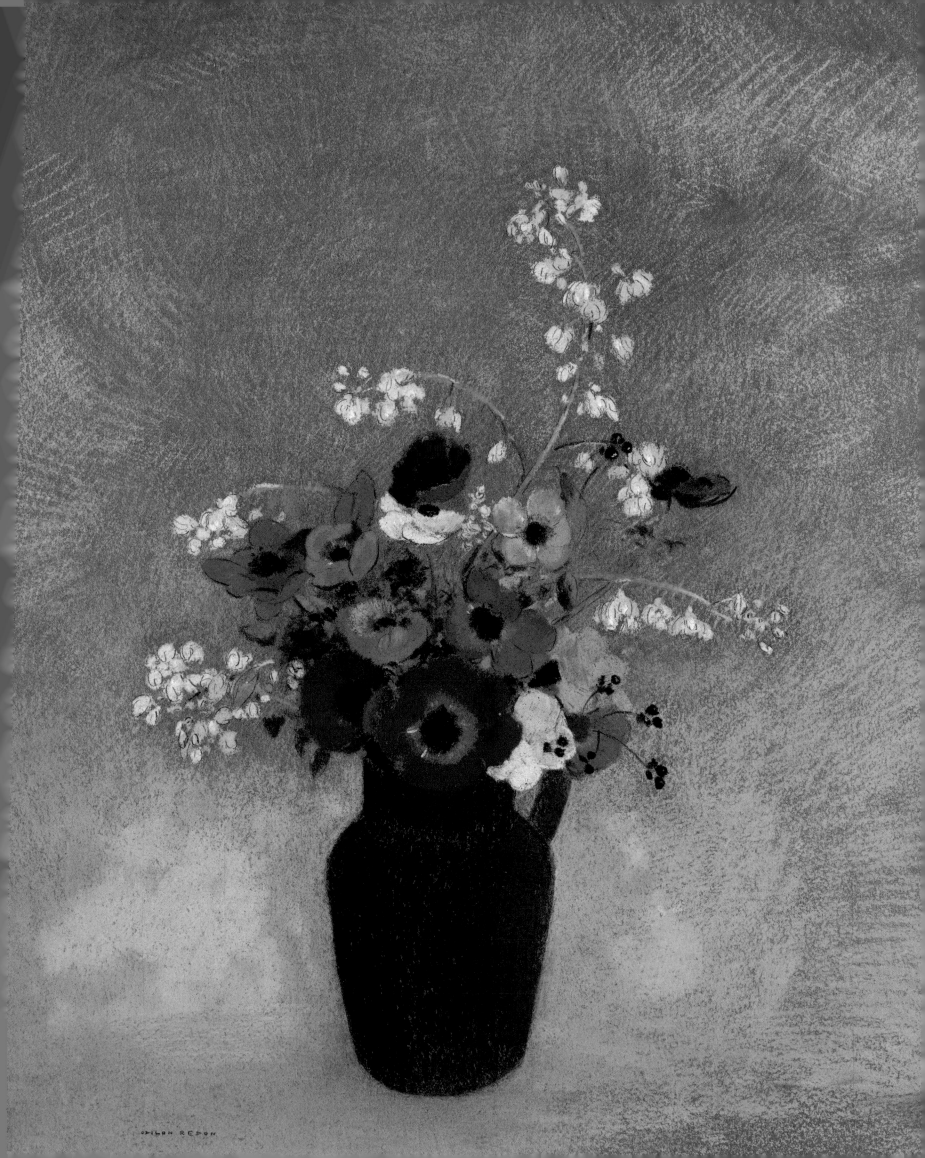

ODILON REDON

11

OSCAR CLAUDE MONET

FRENCH, 1840-1926

Waterlilies I
Oil on canvas, 35¼ x 39½ inches
Gift of Edward Jackson Holmes. 39.804

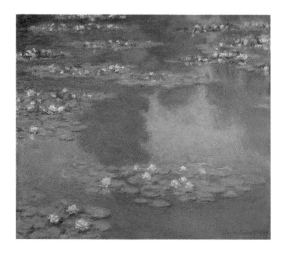

During the 1890s, Claude Monet enlarged his flower garden at Giverny with the purchase of a strip of marsh land across the road. With the help of workmen, he transformed this unimpressive bit of landscape into a delectable landscape pool traversed by a Japanese footbridge. Near the edge of the pool he planted weeping willows, bamboo, irises, and roses. Several varieties of waterlilies took root in the water. The contemplation and depiction of this water garden was the preoccupation of Monet's later life. His days were spent in meditation at the site transfixed by the opening and closing of the waterlilies and the mirrored images of the clouds passing through them. This beautiful version of the waterlily theme, with its cool bluish-lavender tones rendered in soft focus, suggests a perfect blending of earth and sky through the imagination of the artist.

Claude Monet 1905

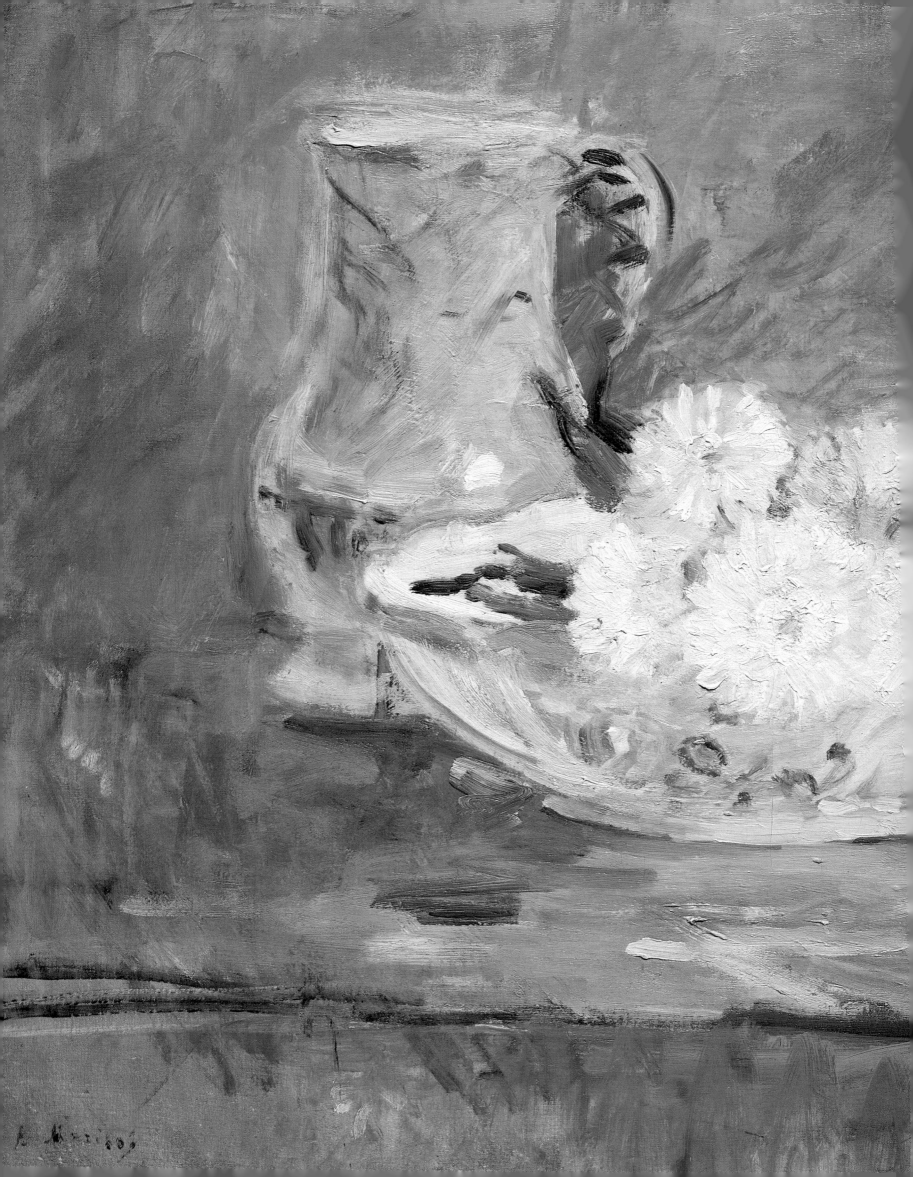

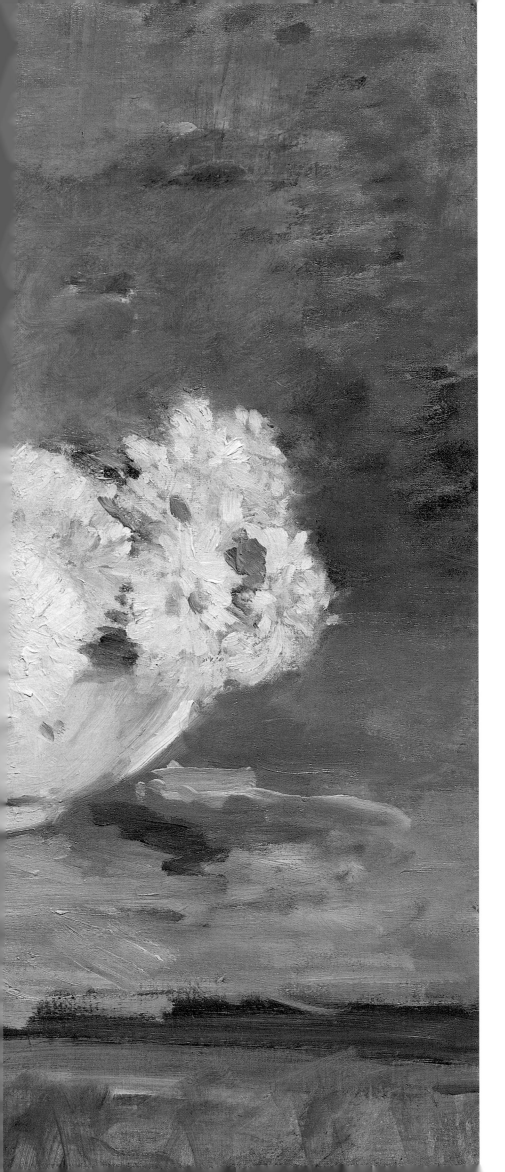

12

BERTHE MORISOT

FRENCH, 1841–1895

White Flowers in a Bowl
Oil on canvas, 18⅛ x 21⅝ inches
Bequest of John T. Spaulding. 48.581

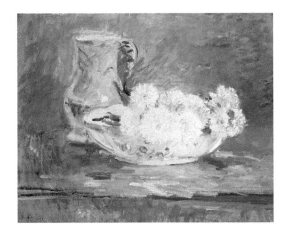

Berthe Morisot, born in Bourges, was the only female painter to join the first exhibition, in 1874, of painters dubbed the "Impressionists." By then, she had received an academic training in art and exhibited at the Paris Salon. She knew a number of the Barbizon painters and had studied with Jean-Baptiste Camille Corot. Edouard Manet became a close friend and strong influence on her artistic development. In 1868, Morisot posed for his painting of the *Balcony*.

However, as this engaging image *White Flowers in a Bowl* indicates, it was the approach of Impressionism that magnetized her style. The bright colors and loose brushwork of this still life dissolve the solid forms of the pitcher and bowl filled with cut flowers into a rich display of pigment. There is no suggestion of weight, volume, or deep space to interfere with the lively visual immediacy of this floral still life.

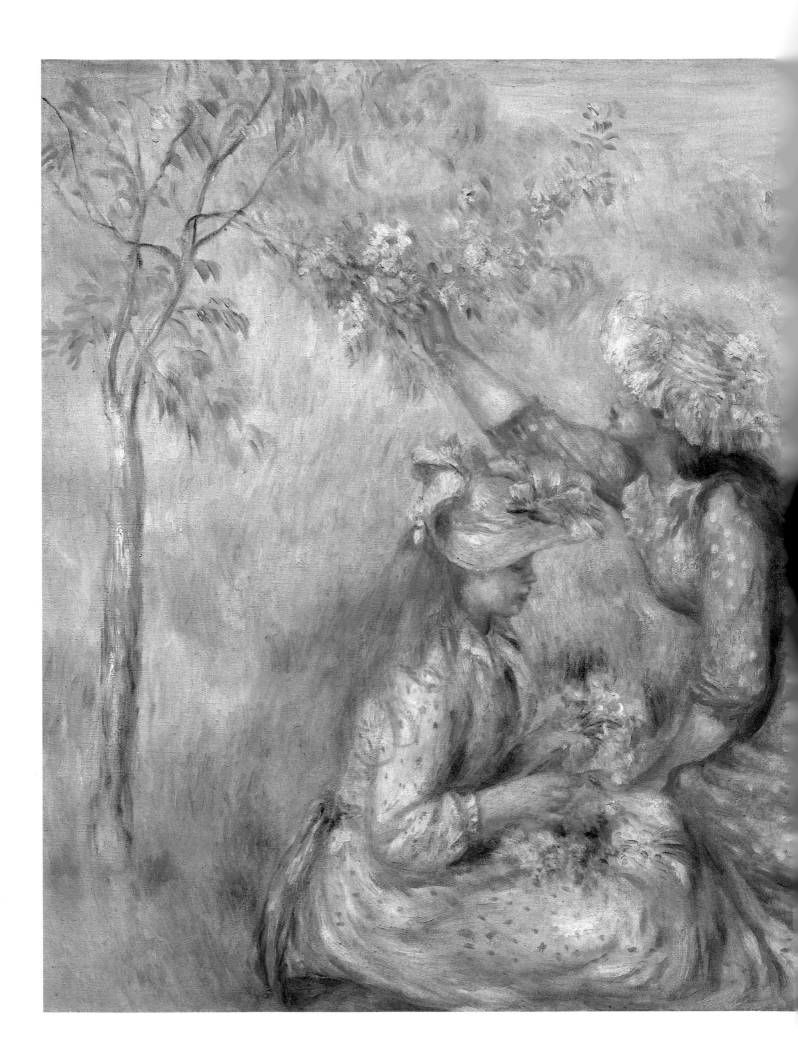

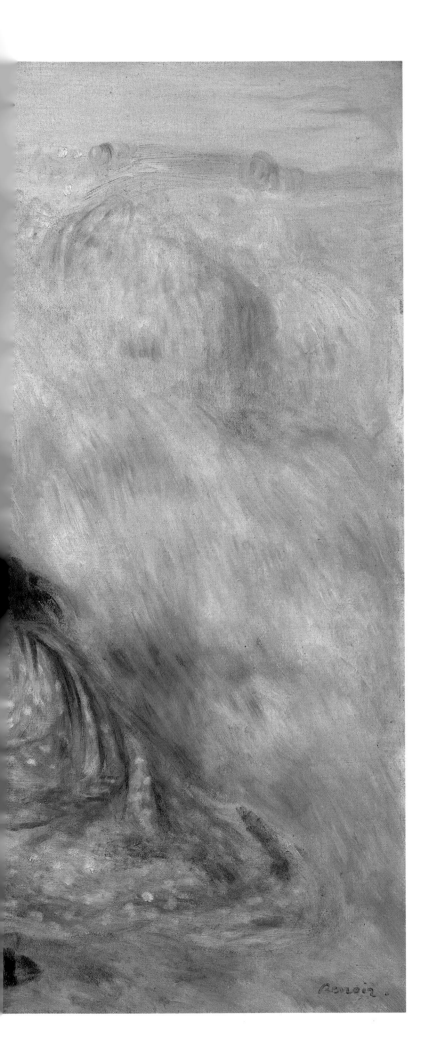

Pierre Auguste Renoir

French, 1841–1919

Girls Picking Flowers in a Meadow
Oil on canvas, 25⅝ x 31⅞ inches
Juliana Cheney Edwards Collection. 39.675

During the early 1870s, Pierre Auguste Renoir shared center stage in the development of French Impressionism with Claude Monet. The two artists frequently painted together in Paris and in the suburb of Argenteuil. Whether they were painting the *Pont Neuf* in Paris or a duck pond in the countryside, they emphasized the sensation of color and light and atmosphere inhaled out-of-doors and applied directly onto the canvas with as little interference as possible.

Like some of the other Impressionists, Renoir changed his approach to painting during the 1880s. "Around 1883," he recalled later, "a sort of change occurred in my work. I had gone to the end of Impressionism and I was reaching the conclusion that I didn't know how either to paint or draw. In a word, I was at a dead end."[1] Renoir then moved away from painting outside, where the changes in nature now seemed distracting, in order to recapture the solidity of form that he found lacking in his earlier work.

Girls Picking Flowers in a Meadow, a late painting by Renoir, shows two young girls in flowered bonnets who are picking and gathering a bouquet in a landscape setting. The glistening pastel tonality of the work retains the veneer of the bright Impressionist palette, but the strong volumes of the figures and their distinct contours reflect the artist's remove to more traditional artistic values. Although Renoir was plagued by painful rheumatism in his fingers, often working with brushes attached to his wrist, his late work retains its delight in the pleasures of life and art. This painting is a visual ode to the enjoyment of flowers, and women, and nature.

[1] John Rewald, *The History of Impressionism* (New York: The Museum of Modern, 1961), p. 486.

HENRY RODERICK NEWMAN

AMERICAN, 1843–1917

Wildflowers, 1887
Watercolor on paper, 15 x 10 inches
Gift of Denman W. Ross. 17.1418

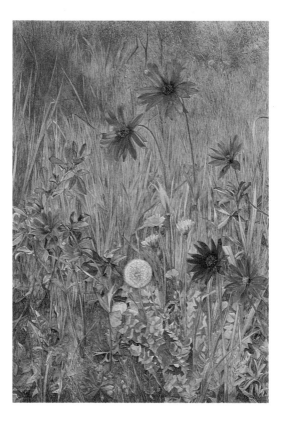

"Mr. Newman selects foregrounds full of flowers and paints these foregrounds at the shortest possible range" commented an appreciative writer in the 1880s about a composition similar to *Wildflowers,* painted in 1887.[1] With this insect's view of nature, Henry Roderick Newman encourages us to kneel down and observe carefully these natural growing forms, almost uncomposed by his brush and without the interference of a sky, a tree, or a brook to provide a specific landscape context. This myopic perspective provides a direct communion with the inherent beauties of nature and bears comparison with the transcendental philosophy of Henry David Thoreau, who believed that nature, being perfect in every detail, would bear the closest inspection. Newman uses a detailed, almost graphic handling of the watercolor medium to define the contours of every petal, leaf, blossom, and blade of grass. The pink, yellow and white blossoms are displayed against "a background of that light green peculiar to the Springtide grass of Tuscany," where the painting was made.[2] Only in the distant background of this small work, where a hint of air and sunlight appears in the upper right-hand corner, do the forms of nature dissolve into atmosphere.

Born in Easton, New York, Newman later had a studio in New York City, but he developed his love for nature during summer stays in Massachusetts and in the Green Mountains of Vermont. The aesthetic ideas of the English art critic, John Ruskin, which were published in America in two periodicals, *The Crayon* and *The New Path,* between 1855 and 1865, encouraged Newman and his fellow American Pre-Raphaelite painters to study nature's least conspicuous details and represent their delicate beauty. Newman became an intimate friend of Ruskin and they traveled together through Italy after Newman's remove to Florence in the 1870s.

[1] Henry Buxton Forman, "An American Studio in Florence" *The Manhattan,* Vol. 3 (June 1884), p. 533–4, quoted in Linda Ferber and William H. Gerdts, *The New Path: Ruskin and the American Pre-Raphaelites,* New York: Brooklyn Museum, 1985, p. 211.

[2] *Ibid.*

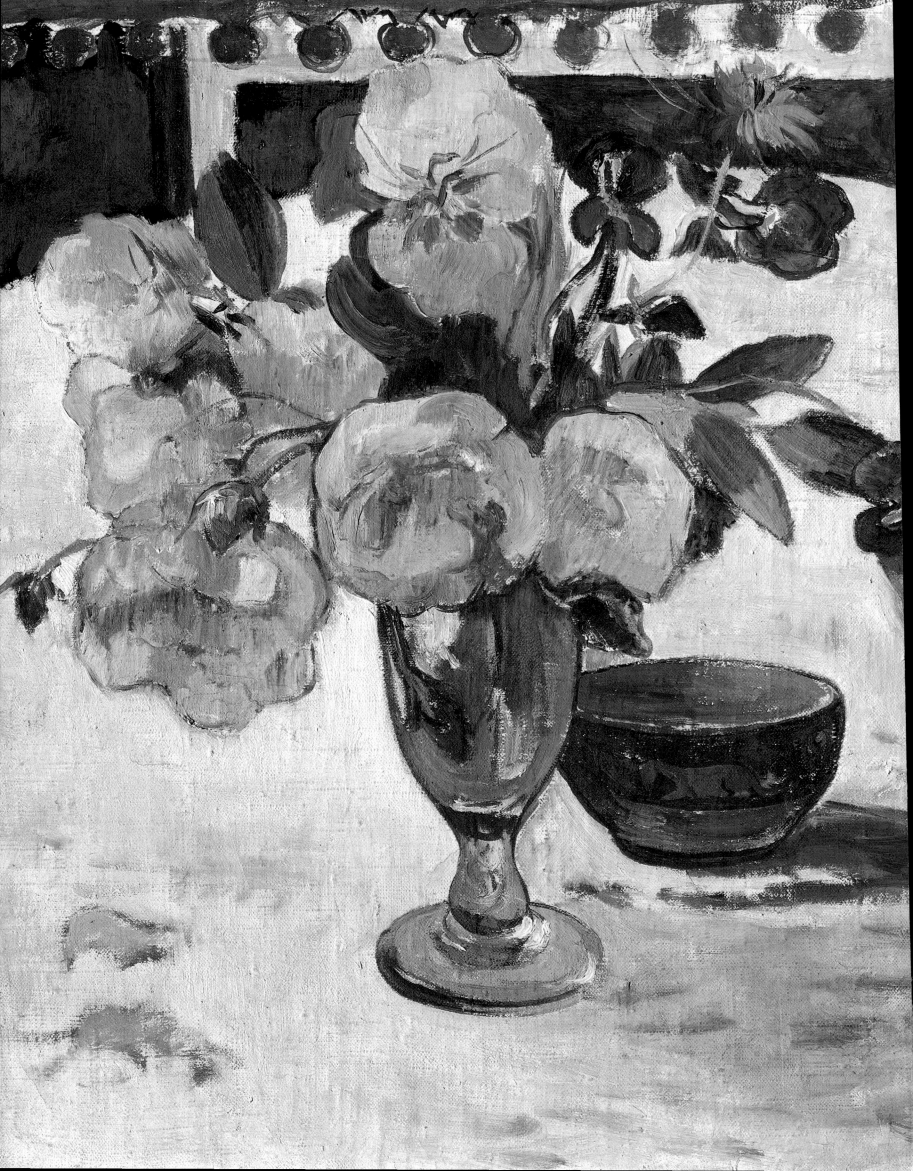

PAUL GAUGUIN

FRENCH, 1848–1903

Flowers and a Bowl of Fruit on a Table
Oil on canvas mounted on paperboard, 16⅞ x 24¾ inches
Bequest of John T. Spaulding. 48.546

Before his departure for Tahiti in 1891, Paul Gauguin was stretching the boundaries of his painting style. Selecting a still-life subject for its abstract rather than its descriptive potential, he challenged himself to do "something else than what I know how to do." In this painting, space is compressed by the flipped-up tabletop. Color is applied with arbitrary *élan* and shadows take on a life of shape and pattern that is independent of the objects to which they are attached. Although far removed from the figure and landscape subjects of the South Seas for which he is best known, this *Flowers and a Bowl of Fruit on a Table* suggests Gauguin's desire to free himself from the description of nature. Indeed, he once boasted that he was not a painter after nature. "My artistic center is in my brain, and nowhere else, and I am strong because . . . I do what is within me."[1] This still life bears the strong imprint of the artist's inner vision.

[1]Robert Goldwater, *Paul Gauguin* (London: Thames and Hudson, [no date]), p. 33.

16

JOHN SINGER SARGENT

AMERICAN, 1856–1925

Miss Helen Sears (Mrs. J. D. Cameron Bradley)
Oil on canvas, 65¾ x 35¾ inches
Gift of Mrs. J. D. Cameron Bradley. 55.1116

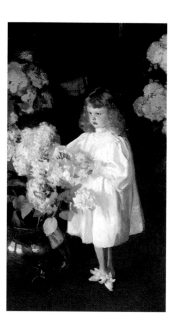

Born in Florence to American parents, John Singer Sargent traveled a great deal during his youth. In 1874 his family settled in Paris where Sargent studied painting at the Ecole des Beaux-Arts and in the studio of the progressive academic artist Émile Carolus-Duran. By the time he painted this portrait of *Miss Helen Sears* in 1895, he had established himself as one of the preeminent masters of fashionable portraiture in the tradition of the English painter Sir Joshua Reynolds. He painted friends, artists and distinguished society figures in Boston, New York, and London.

In this intimate portrayal of a young girl with flowers, Helen Sears, dressed in vivid white, stands next to a copper pot filled with a bouquet of cut blue, lavender, and white hydrangeas. The large size of the blooms makes the child appear diminutive and vulnerable. In fact, the artist's similar treatment of the flowers and the child, both shown brilliantly highlighted against a rich but somber ground, and their overlapping forms suggests a relationship between the two. The innocent beauty of the child shares with the bouquet an expression of vitality and fragility. Sargent suggests that, due to their ephemeral nature, beauty and youth are to be enjoyed all the more.

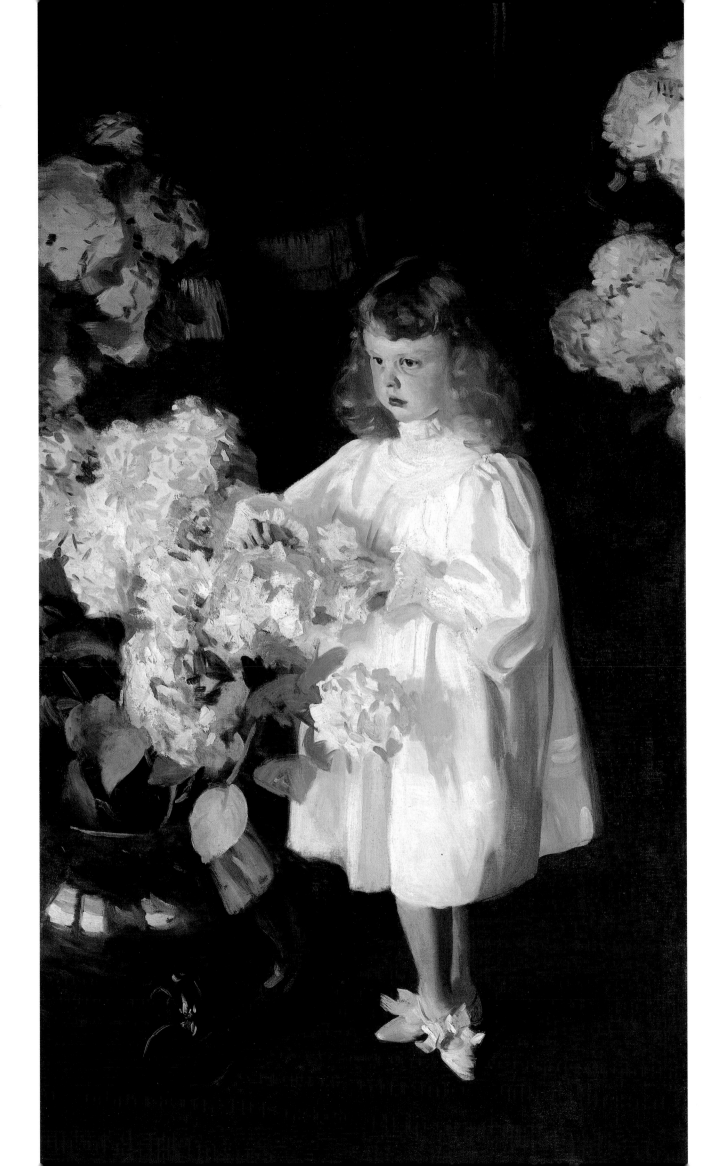

Maurice Brazil Prendergast

American, 1859–1924

Flowers in a Blue Vase
Oil on canvas, 19 x 16 inches
Bequest of John T. Spaulding. 48.589

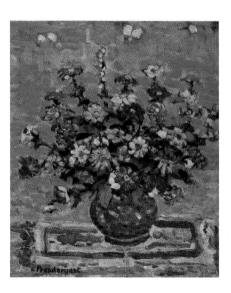

Maurice Prendergast grew up in Boston and began painting there. However, it was his trips to Europe, beginning in 1884, and especially those to Paris, that influenced the development of his style. He was one of the earliest American artists to appreciate the accomplishments of Cézanne, whose work he admired because it "left everything to the imagination." He found the French master's watercolors particularly impressive because of "their simplicity and suggestive qualities."[1] Prendergast's paintings of Venice, Paris, and French seaside resorts, as well as festive images of New York's Central Park, represent the shapes and colors of people and places without descriptive detail or narrative content.

When this still life of *Flowers in a Blue Vase* was painted in about 1915, Prendergast had moved to New York with his brother Charles and had begun to limit the subjects of his art principally to bathing figures at the beach and to fruits and flowers. With his own form of pointillist technique, his colorful brushwork takes on a life of its own almost independent of the objects it describes. Here the background, the vase, and the support share center stage in their formal emphasis, while the flowers create a tapestry of color and design without a special focus.

It was about ten years earlier that Prendergast had first recognized the potential of flowers as a subject of interest to him. In a letter to a friend and fellow artist, Ester Williams, he wrote, "I am gradually coming around to flowers and you knocked into my head that . . . something great can be painted with them."[2]

[1]Maurice Prendergast, Paris, October 10, 1907, Letter to Ester Williams, Archives of American Art, Smithsonian Institution, Washington, D.C.

[2]Maurice Prendergast, March 5, 1905, Letter to Ester Williams, Archives of American Art, Smithsonian Institution, Washington, D.C.

18

EMIL NOLDE

GERMAN, 1867-1956

Iris
Watercolor, 18½ x 13½ inches
Seth K. Sweetser Fund. 57.667

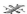

Christened Emil Hansen, the artist changed his name to Nolde later in life after the small town along the Baltic coast in northern Germany where he was born. Although suffering from acute loneliness, he spent his early life traveling through Europe, in order to educate himself about art, and found jobs to support himself during the search. He took formal lessons in Munich, sketched the mountains in Switzerland, and familiarized himself with Impressionism in Paris. Nolde's marriage in 1902 to a Danish girl, Ada Vilstrup, cured his loneliness but not his poverty. His first formal engagement in the world of art took place in 1907 when he joined the revolutionary Dresden artists' group *Die Brücke* (The Bridge) and participated in their group shows and efforts to gain acceptance for a new, still unnamed kind of painting that would come to be called Expressionism.

Nolde's autobiographical writings reveal an isolated personality, desperate for friendship and plagued by his own inability to participate in normal human intercourse. Art and nature provided the creative outlets for his intense internal experiences. Throughout his life, he experienced deep religious feelings and painted mystical biblical scenes. He also loved gardens and when, in 1927, he built a studio and home called Seebüll on the northern coast of Germany near his birthplace, he cultivated a lush flower garden. He had painted gardens as early as 1906, but the majority of his floral subjects were plucked from the Seebüll garden.

Nolde depicted flowers in both vases and outdoor gardens, however, his most evocative images, like this grouping of *Iris*, are removed from environmental relationships. The *Iris* are treated with a watercolor technique that he developed after a trip to the Orient. Using absorbent Japanese paper, he wet the surface and then applied the watercolor, allowing the pigments to flow and blend with each other and stopping their movement with a tuft of cotton. The resonant vibrancy and subtle color modulations in the white, blue, and yellow irises and their mysterious atmospheric setting depend in part on Nolde's revolutionary watercolor technique. The artist used it to give visual projection to his strong association of plant life with human life. "The blossoming colors of the flowers and the purity of those colors — I love them," he wrote. "I loved the flowers and their fate: shooting up, blooming, radiating, glowing, gladdening, bending, wilting, thrown away and dying."[1]

[1]Peter Selz, *Emil Nolde* (New York: Museum of Modern Art, 1963), p. 49.

19

HENRI MATISSE

FRENCH, 1869–1954

Vase of Flowers
Oil on canvas, 23⅞ x 29 inches
Bequest of John T. Spaulding. 48.577

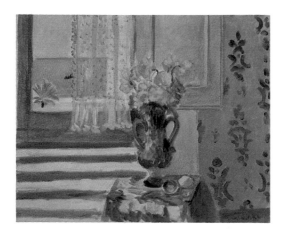

Henri Matisse disliked the long, cold winters in the north of France, so in 1916 he sought refuge in the south, taking a room at the Hôtel Beau-Rivage in Nice overlooking the Mediterranean Sea.

Presenting the theme of the bouquet by the window, *Vase of Flowers* inspires Matisse's appetite for color and light as it interacts at the junction of the interior and exterior world. He incorporates the window view into the design as one of a number of patterned surfaces against which to set the bouquet. The stripes and dots and suggestive squiggles of the wallpaper, curtain, and tablecloth enliven the fabric of empty spaces. The artist's strong sense of compositional balance allows him to surround the floral subject with a variety of ornamented surfaces without destroying the harmony of the whole.

Earlier, Matisse described the central role of composition in his approach to painting. "The whole arrangement of my picture is expressive. The place occupied by figures or objects, the empty spaces around them, the proportions, everything plays a part," he wrote. "Composition is the art of arranging in a decorative manner the various elements at the painter's disposal for the expression of his feelings."[1] The familiar objects in the ordinary setting presented in *Vase of Flowers* take on an air of monumentality that seems to have been achieved by a slight of hand.

[1] Henri Matisse, "Notes of a Painter," 1908, quoted in Herschel B. Chipp, *Theories of Modern Art: A Source Book by Artists and Critics* (Los Angeles: University of California Press, 1970), p. 132.

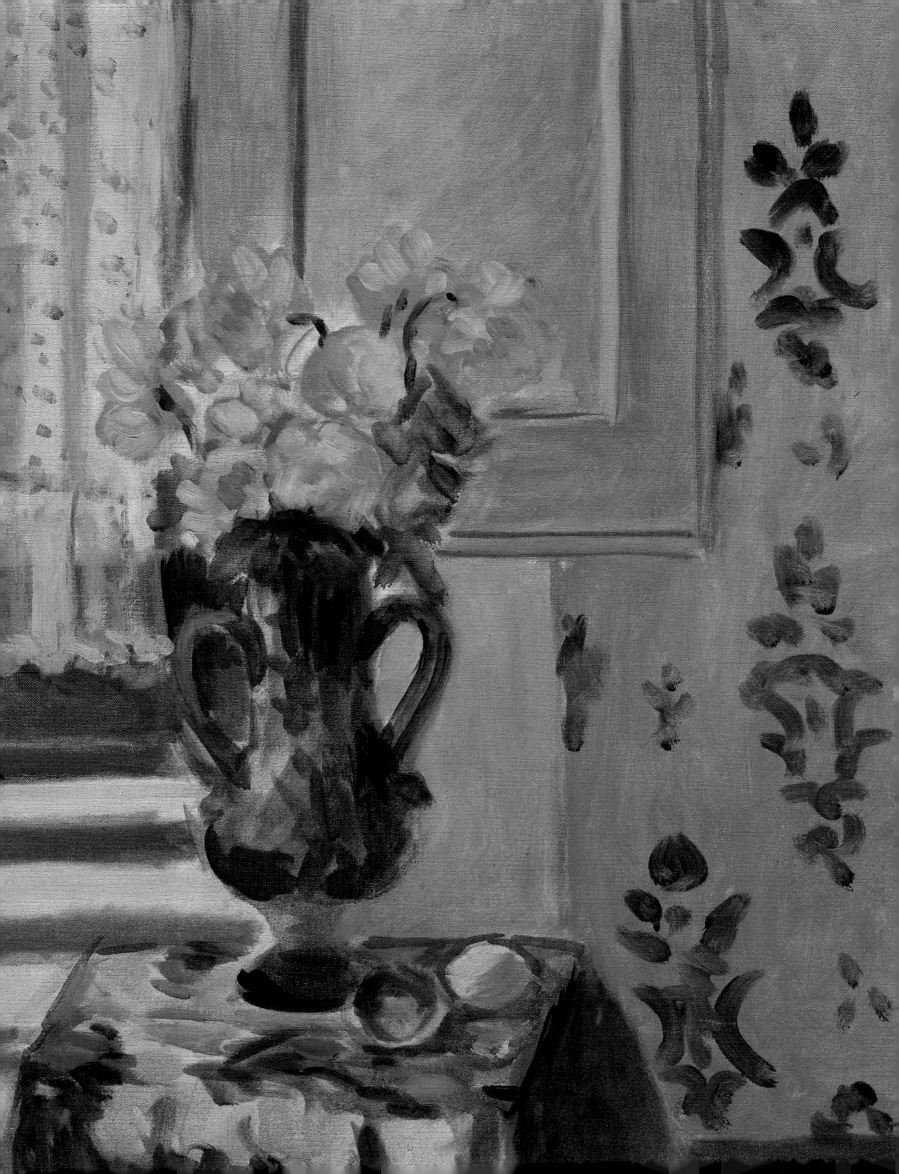

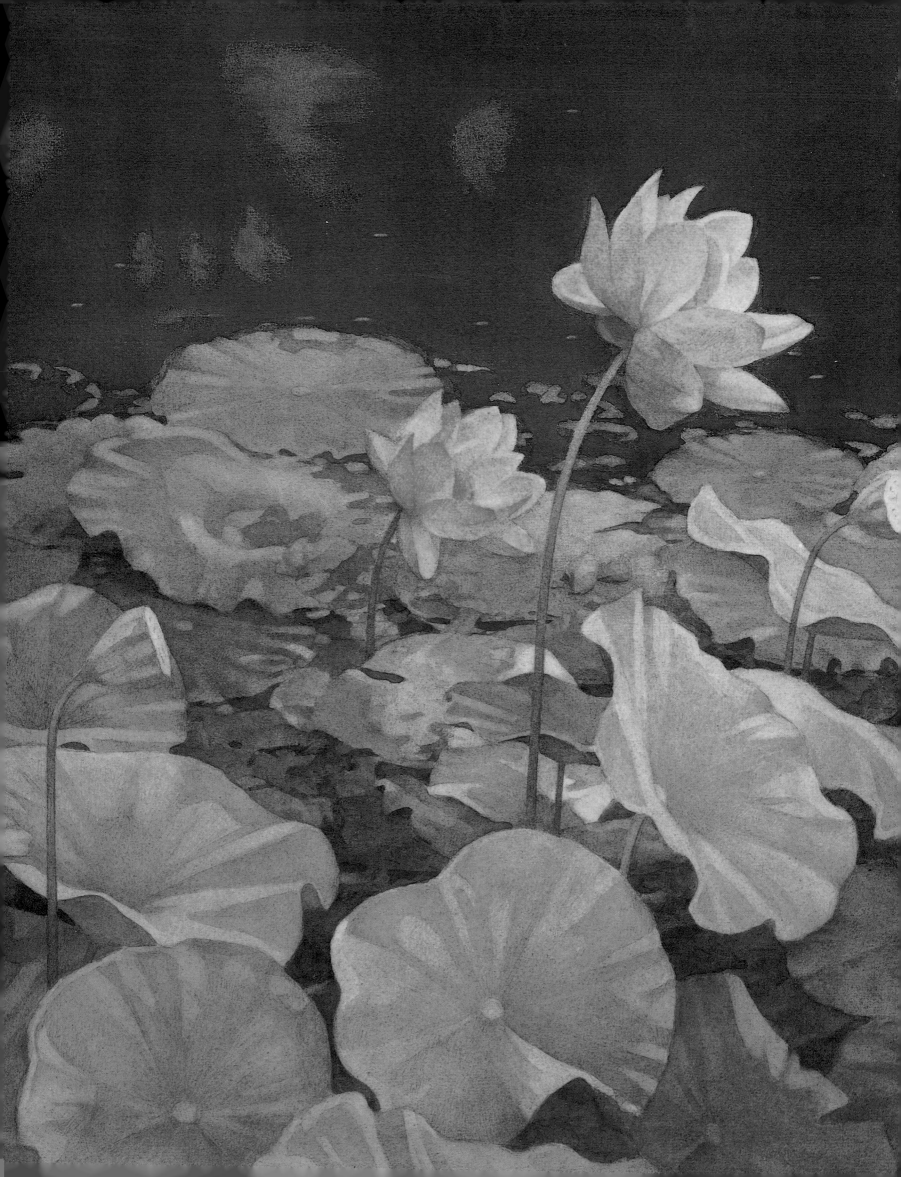

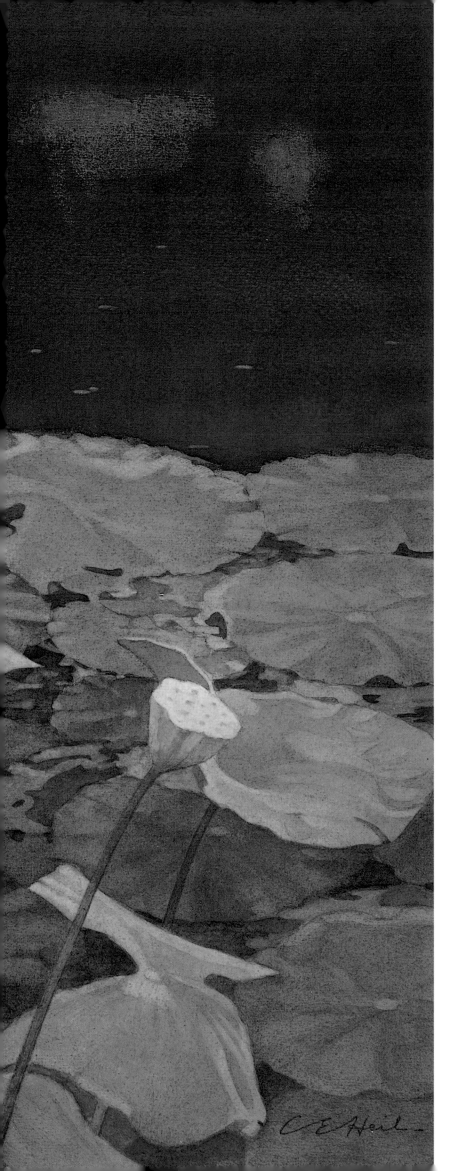

CHARLES EMILE HEIL

AMERICAN, 1870–1950

Lotus
Watercolor, 16 x 22 inches
Museum Purchase. 43.1310

Charles Emile Heil was born in Boston in 1870 and he studied art in his native city as well as in France. Although he worked in oil and various graphic modes, watercolor provided the best medium for his nature paintings. Following in the distinguished tradition of such western bird and flower painters as Mark Catesby, Alexander Wilson, and John James Audubon, Heil approached the natural world as an explorer determined to capture its appearance with accuracy and sensitivity. Many of his small-scale watercolors show such common birds as warblers and sparrows perched on blossoming branches of fruit trees, and follow the botanical tradition of isolating specimens on a neutral ground.

In the painting of the *Lotus*, however, Heil displays the pale pink blossoms and yellow seed pods of the flower in a lush natural environment defined by the broad leaves of the plant and a deep green background. It is through the treatment of the plant that the artist conveys to us the nature of its setting. The aquatic habitat of the *Lotus* is suggested by a quilt of decorative patterned reflections on the otherwise indistinguishable pool of water. The flowers and leaves also tell us the direction of the sunlight by bending gently to the right to bask in its warmth and essential nutritive properties.

21

JOSEPH STELLA

AMERICAN, 1877–1946

Cactus and Tropical Foliage
Watercolor over graphite, 18½ x 24⅛ inches
Sophie M. Friedman Fund. 1984.412

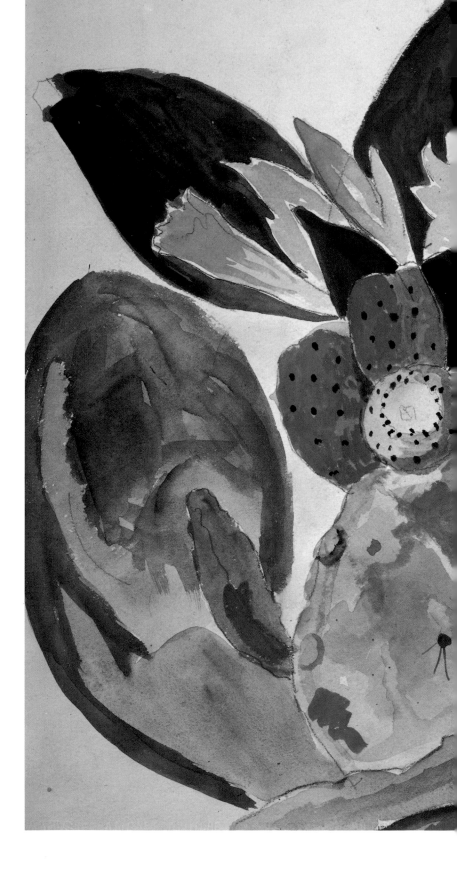

Born in Naples, Italy, Joseph Stella came to New York in 1896, but he returned to Europe in 1909 to study art and became an intimate member of the Futurist circle of painters. He adapted the avant-garde style of the old world to the subjects of the new by presenting splintered representations of such New York City landmarks as Coney Island and the monumental Brooklyn Bridge. But later, as this fine watercolor of *Cactus and Tropical Foliage* indicates, he turned to botanical subjects.

Stella remembered that "from 1921 on I was swinging as a pendulum from one subject to the opposite one. With sheer delight I was roaming through different fields spurred by the inciting expectation of finding thrilling surprises, especially going through the luxuriant botanical garden of the Bronx. I was seized with a sensual thrill in cutting with the sharpness of my silverpoint the terse purity of the lotus leaves or the matchless stem of a strange tropical plant."[1]

Stella describes the flowering cactus in this painting with a combination of sensuous color and precise contour. The loose brushwork and varied transparencies of the watercolor medium enrich the expression of this informal botanical sketch which surely is a response by the artist to a live specimen at a botanical garden or one encountered during his travels in the tropics.

[1] Joseph Stella, "Autobiographical Notes," copy of a transcript given to Lloyd Goodrich by Joseph Stella, February 1946. Artist file, Whitney Museum of American Art.

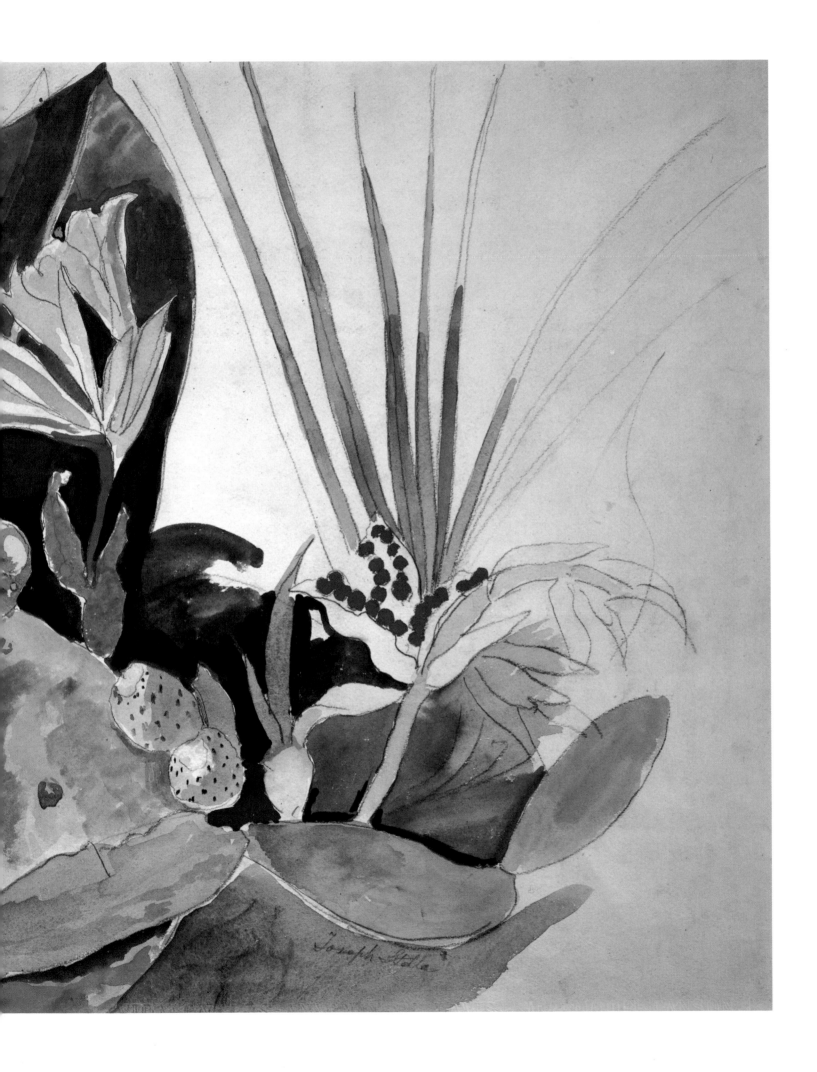

Joseph Stella

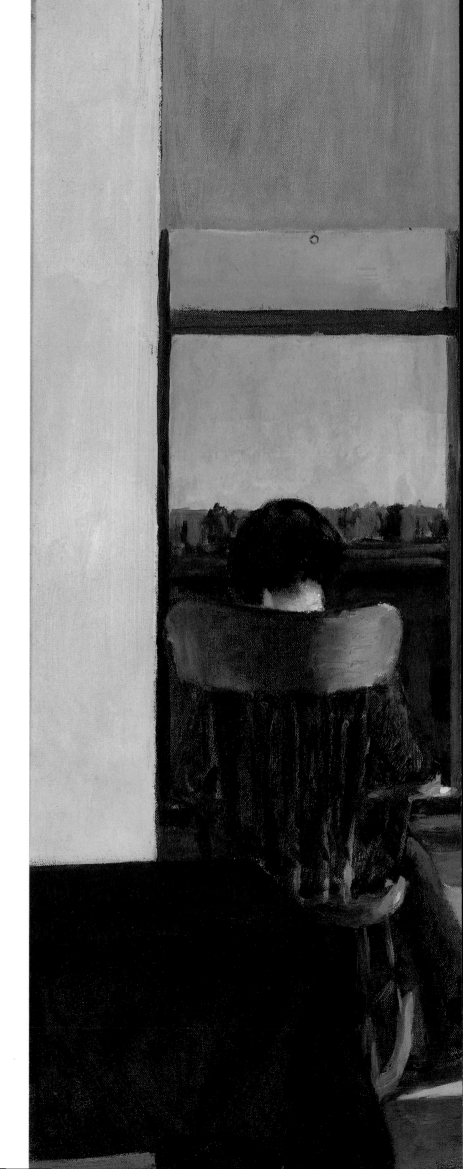

22

Edward Hopper

American, 1882–1967

Room in Brooklyn
Oil on canvas, 29 x 34 inches
The Hayden Collection. 35.66

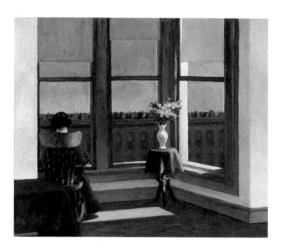

The theme of women in interiors is a dominant
one in the work of Edward Hopper, who is
considered perhaps the foremost American
realist painter of the 20th century. *Room in
Brooklyn*, painted in 1932, depicts a woman seen
from behind and centered before a window
overlooking the rooftops of a row of townhouses.
Despite her proximity to the window, she is not
engaged in the view but locked in solitary
contemplation inside. The vase of flowers set on
a tabletop is juxtaposed to the figure and acts as
a formal and expressive foil. While the woman
is cast in shadow, the bouquet of flowers basks in
the warmth of the sun's rays. The bright color of
the blossoms and the voluptuous shape of the
container seem to vibrate with life while the
human figure appears inanimate. The mys-
terious interplay of the figure and the bouquet
is heightened by the stark simplification of
the setting. This *Room in Brooklyn*, according to
Hopper, is his only painting to include the
subject of flowers. He didn't paint flowers, he
said, because "the so-called beauty is all there.
You can't add anything to them of your own —
yourself."[1]

[1] Brian O'Doherty, *American Masters: The Voice and the Myth*
(New York: Universe Books, 1988), p. 41.

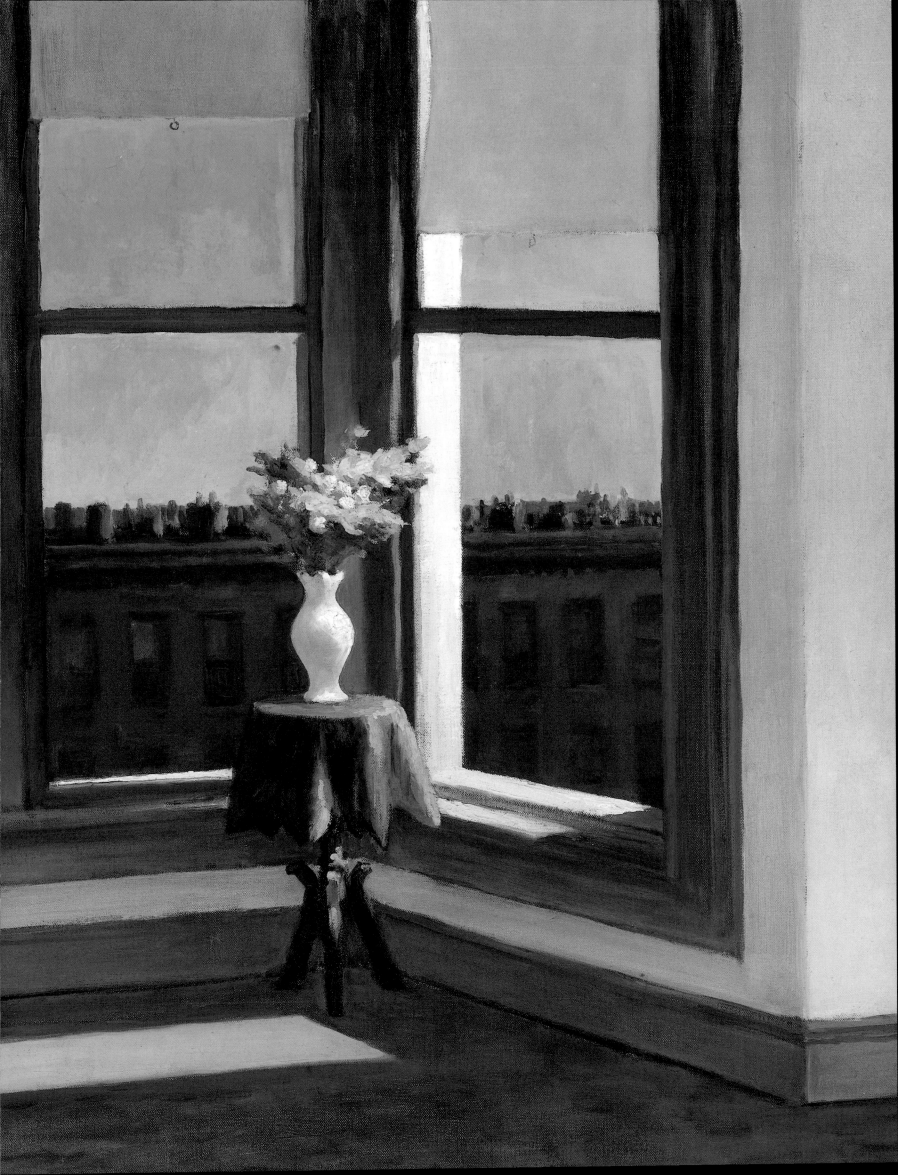

CHARLES DEMUTH

AMERICAN, 1883–1935

Zinnias and Daisies, 1925
Watercolor, 17½ x 11⅜ inches
Frederick Brown Fund. 40.231

This delicate floral watercolor *Zinnias and Daisies* was painted during the 1920s when, like Georgia O'Keeffe, Charles Demuth concentrated on images of architecture and flowers. In this combination of brightly hued, robust zinnia blossoms with the muted tones of the more delicate forms of the black-eyed susan, Demuth makes direct reference to the symbolic association of flowers with the life cycle. Almost obscured by the transparent washes of brown, which provide an indefinite but tangible space for the flowers, a lightly penciled notation by the artist reads "youth and old age." In spite of the title, the blossoms are not clearly represented at different stages of bloom to suggest floral equivalents of youth and maturity. Perhaps, instead, the quote refers to the artist's lifelong attraction to the magnetic beauty of flowers in nature. In an unpublished short story, Demuth wrote: "A young man (to call him a genius would have flattered him) was painting in a garden. . . . All the objects in the garden took from the light, for the moment, some of its color and quality and added them to their own. When the young man began to paint, all things seemed to him to glitter and float in a golden liquid, so dazzling was the scene."[1] This absorption of nature into floral form is captured by Demuth in the radiant glow of his zinnias and daisies.

[1]Charles Demuth, "In Black and White," unpublished short story, in Emily E. Farnham, "Charles Demuth: His Life, Psychology and Works," unpublished dissertation, Ohio State University, 1959, Vol. 3, p. 924.

24

MARC CHAGALL

RUSSIAN, WORKED IN FRANCE, 1887–1985

Village Street
Oil on canvas, 18⅛ x 15 inches
Bequest of Anna Feldberg. 1978.156

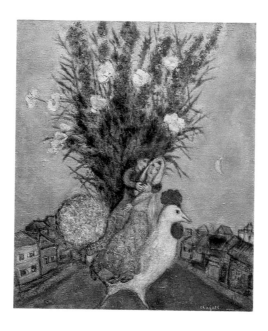

Born of a Hasidic Jewish family in Vitebsk, a provincial Russian town, Marc Chagall spent the greater part of his long artistic life in Paris. Although he and his wife Bella never returned to Vitebsk after 1923, the recollection of their home town figures in all of the artist's work. "In my pictures," wrote Chagall in his *Autobiography* of 1931, "there is not one centimeter free from nostalgia for my native land."[1]

However, it was in France that Chagall was touched by a succession of stylistic movements, including Fauvism, Cubism, and Surrealism, which impressed his development as an artist but never branded him as a follower of any one. It was also in France that Chagall was first struck by the beauty of flowers. He remembered encountering his first bouquet in the town of Toulon in 1924. So impressed was he by the experience that, for him, bouquets would always represent France.

In the painting the *Village Street*, a lavender and white bouquet fills the sky with the joy of the embracing wedding couple below. The whole group is perched on the back of a large rooster standing majestically in the middle of a narrow village street. The brightly colored, carefully drawn elements in this composition are presented in nonnaturalistic concert. Are we in France or Russia? Is this Vitebsk or Toulon? Are the lovers Chagall and Bella or ideal representations of love? What does the rooster signify? The questions called up by the enigmatic relationship between these clearly recognizable pictorial elements comprise one of the work's many challenges. Although some of these pictorial elements — flowers, lovers, and roosters — appear repeatedly in the artist's repertoire, Chagall claimed in 1946: "I don't understand them at all. They are not literature. They are only pictorial arrangements of images that obsess me."[2] Enigmatic symbolism and the singular combination of reality with unreality stamp every work by Chagall as distinctively his own.

[1] Roy McMullen, *The World of Marc Chagall* (Garden City, N.Y.: Doubleday & Co., Inc., 1968), p. 143.

[2] James Johnson Sweeney, *Marc Chagall* (New York: Museum of Modern Art, 1946), p. 7.

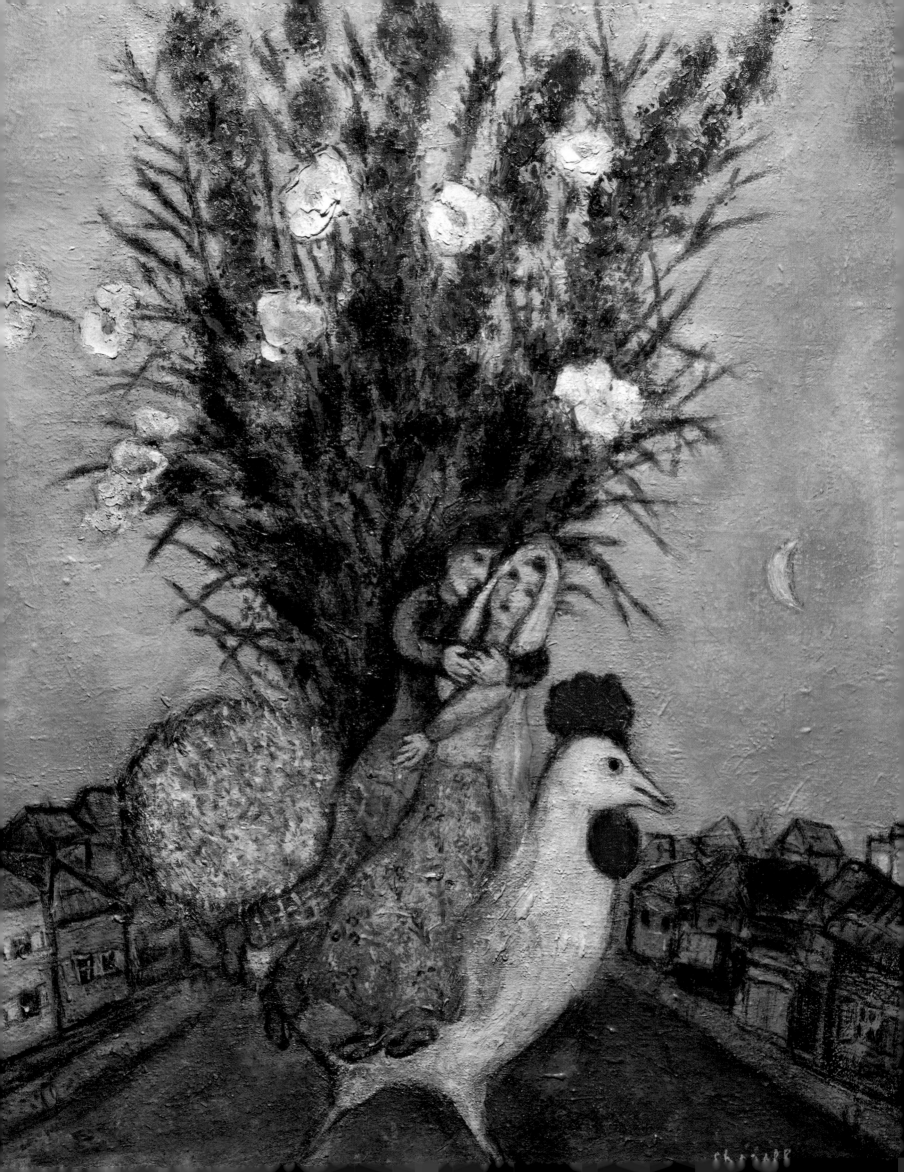

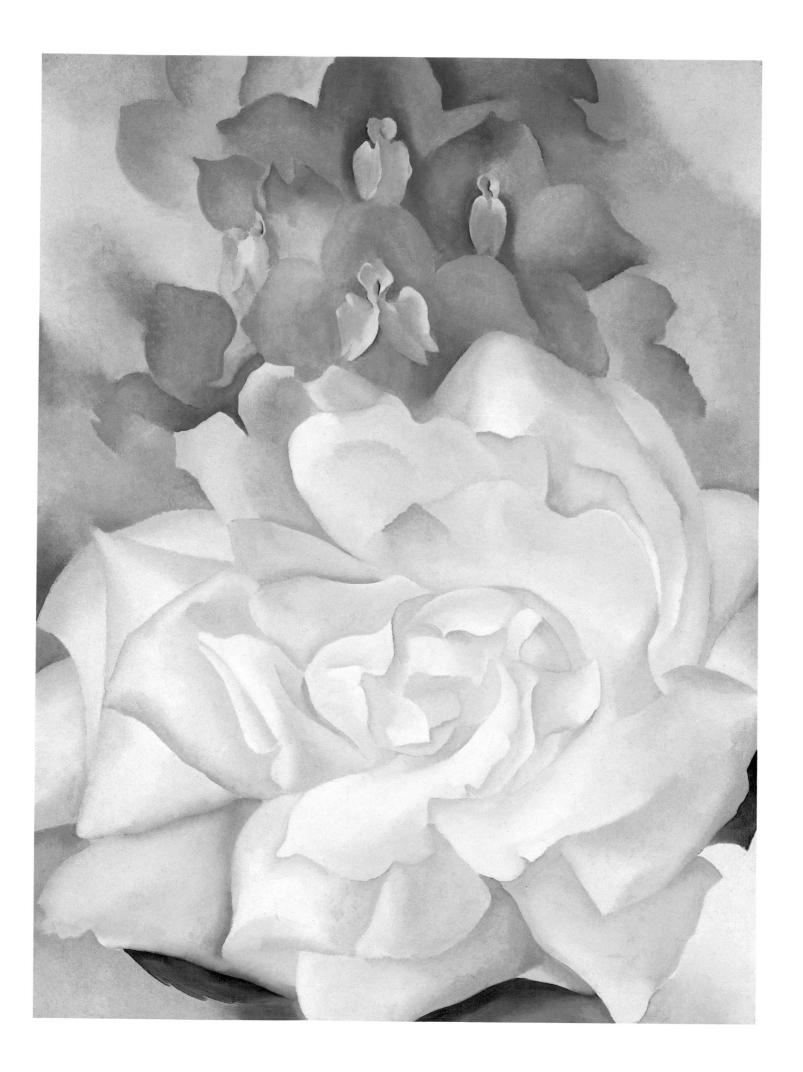

25

Georgia O'Keeffe

American, 1887–1986

White Rose with Larkspur No. 2
Oil on canvas, 40 x 30 inches
Henry H. and Zoë Oliver Sherman Fund. 1980.207

Throughout her long life, Georgia O'Keeffe maintained her profile as an artist with an independent vision. Even before her move to New York City in 1918, her early abstract watercolors caught the sharp eye of the photographer Alfred Stieglitz, who exhibited them at the influential "291" gallery. These very simple images — two blue lines of varying thickness and intensity of color standing erect on a blue base, for example — emerged from the artist's desire to strip away what she had been taught in order to achieve an expression direct from herself. "I have things in my head," she wrote later, "that are not like what anyone has taught me — shapes and ideas so near to me — so natural to my way of being and thinking that it hasn't occurred to me to put them down."[1] From then on, Georgia O'Keeffe stayed in close contact with her inventive inner vision.

Created in 1927, this magnificent painting of a white rose surmounted by blue larkspur was one of a number of floral images that O'Keeffe produced during the late 1920s. The other subject that preoccupied her at the time was the New York skyline. Her images of skyscrapers and flowers share a paradoxical combination of reduction and expansion.

The rose and the larkspur are divested of all the details of stems, leaves, reproductive parts, and physical support to concentrate on their qualities of shape and color. At the same time, the scale of these small blossoms has been magnified many times in order to fill a canvas measuring 40 by 30 inches. O'Keeffe explained the motivation for this intense enlargement. "Nobody sees a flower really — it is so small — we haven't time — and to see takes time, like to have a friend takes time. If I could paint the flower exactly as I see it no one would see what I see because I would paint it small like the flower is small," she asserted. "So I said to myself — I'll paint what I see — what the flower is to me but I'll paint it big and they will be surprised into taking time to look at it."[2] This arresting image, a fusion of reality and abstraction, does make us look, and think and respond to these vital flowers that retain their connection to nature and the indelible imprint of the artist's personal interpretation.

[1] *Georgia O'Keeffe* (New York: Viking Press, 1976), fig. 1 [unpaginated].

[2] *Ibid.*, fig. 23.

STANTON MACDONALD-WRIGHT

AMERICAN, 1890–1973

Still Life with Arum Lilies and Fruit
Oil on canvas, 22 x 18 inches
Bequest of John T. Spaulding. 48.575

Born in Charlottesville, Virginia, Stanton Macdonald-Wright spent the formative years of his artistic career in Paris, where he lived and worked from 1907 to 1916. With his fellow-American painter Morgan Russell, Macdonald-Wright began to experiment with new and abstract treatments of color in response to recently published scientific treatises on the laws that governed the perception of color. In the introduction to a catalogue for an exhibition of their work in Paris in 1913, Macdonald-Wright described the dominant role of color in his painting. "Form to me is color. When I conceive a composition of form, my imagination creates an organization of color that corresponds to it. . . . Each color has an inevitable position of its own in what could be called 'emotional space' and has also its precise character. I conceive space itself as of plastic significance that I express in color."[1]

By 1923, when this *Still Life with Arum Lilies and Fruit* was painted, the legacy of Macdonald-Wright's early preoccupation with color remains. The vivid but harmonic use of greens, blues and lavenders throughout the still-life composition indicates that the artist still conceives of color as an independent factor in his work. However, he has reintroduced volumes and lines to describe more clearly the look and weight of the objects he describes. About 1920, Macdonald-Wright, like Auguste Renoir, had begun to feel limited rather than liberated by his focus upon pure color as the building block of his style. He needed to go back to the study of form in the old masters (in this case the work of Cézanne) and design in Oriental art to find new directions. This still life, which was produced during the artist's experimental years, reflects the reintegration of line and volume into the artist's work and a subtle sensitivity to the asymmetrical arrangement of the objects on the canvas.

[1] National Collection of Fine Arts, *The Art of Stanton MacDonald-Wright*, introduction by David W. Scott (Washington, D.C.: Smithsonian Press, 1967), p. 11.

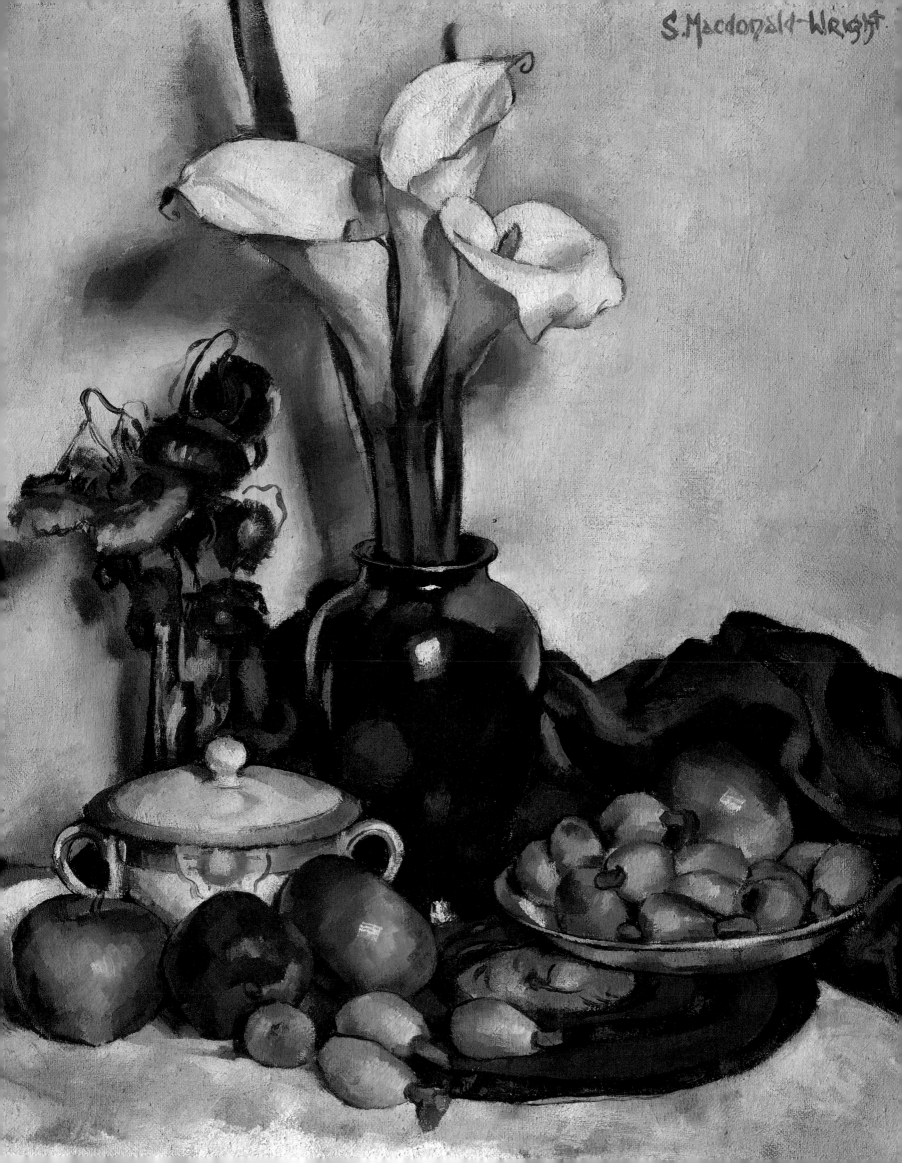

S. Macdonald-Wright

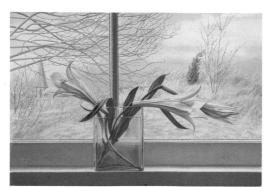

PETER BLUME

AMERICAN, B. 1906

Lilies, 1938
Gouache on paper, 15 x 22 inches
The Hayden Collection. 41.264

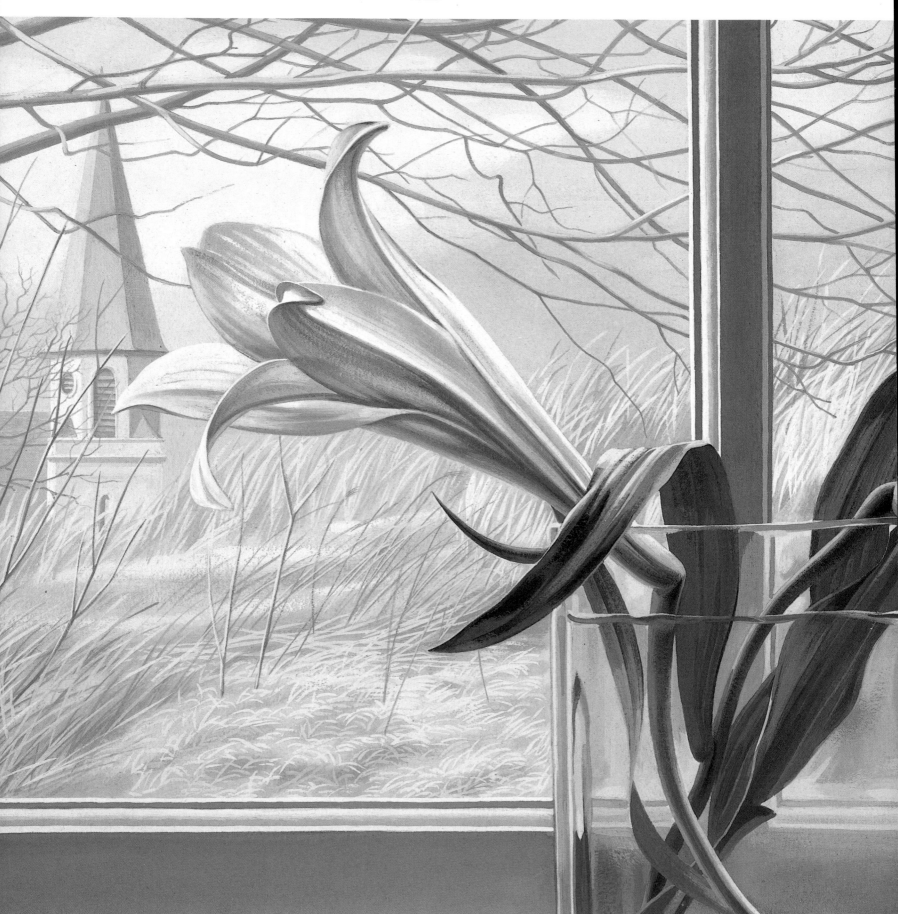

Surrealist painter and muralist Peter Blume was born in Smorgon, Russia, but moved to New York City with his family when he was five years old. Blume's work includes a wide range of subject matter, most of which combines a sharply focused realism with suggestive symbolic overtones. In the gouache rendering of *Lilies*, Blume treats the traditional theme of flowers on a window ledge—the contrast of nature indoors and outdoors. However, in this representation the theme is not one of contrast. The cool tonalities of green, gold, gray and white seem to freeze all the pictorial elements with an icy glaze, and the bleak winter landscape with the church at the left provides a provocative backdrop for the cut lilies. A traditional religious symbol of resurrection, the lily perhaps suggests nature's longing for a release from the grip of winter through the rebirth of spring.

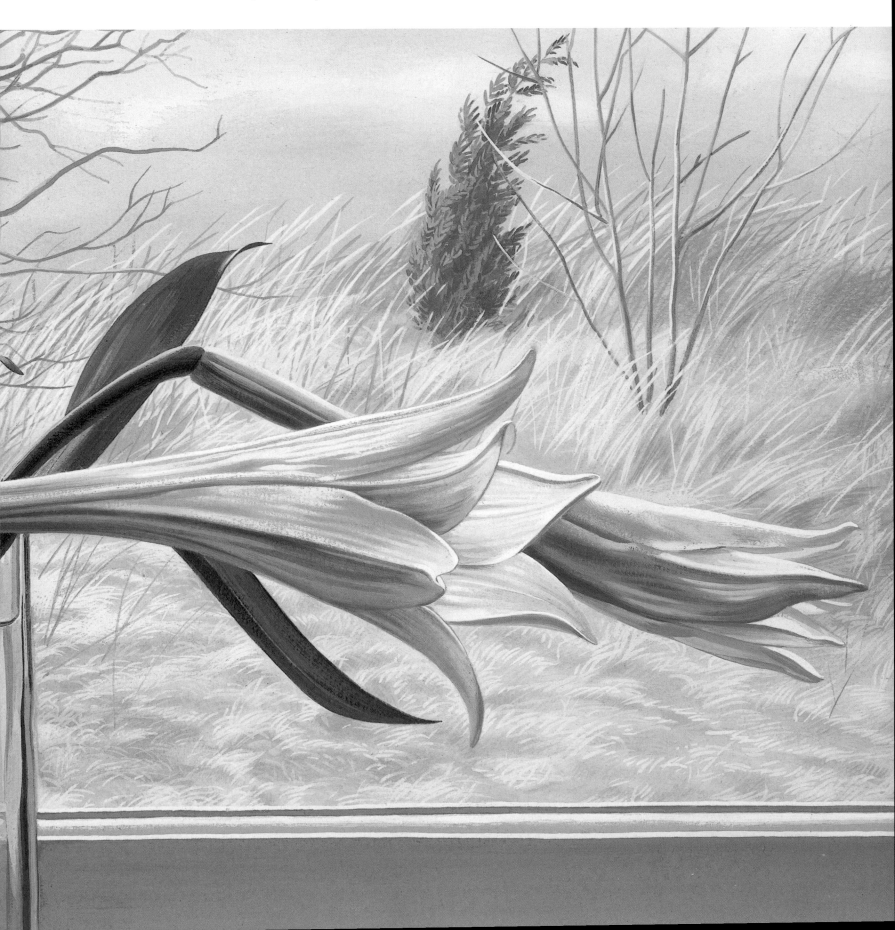

FURTHER READING

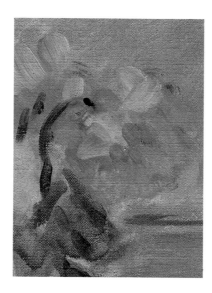

Baur, John I. H. *Nature in Abstraction: The Relation of Abstract Painting and Sculpture to Nature in Twentieth-Century American Art* (exhibition catalogue). New York: The Macmillan Co. for the Whitney Museum of American Art, 1958.

Bergstrom, Ingvar. *Dutch Still-Life Painting in the Seventeenth Century.* Translated by Christina Hedstrom and Gerald Taylor. London: Faber & Faber; New York: Thomas Yoseloff, 1956.

Blunt, Wilfrid, with the assistance of William Stearn. *The Art of Botanical Illustration.* London: William Collins, 1967.

Blunt, Wilfrid, and Sandra Raphael. *The Illustrated Herbal.* London: Frances Lincoln Publishers; New York: Thames & Hudson in association with the Metropolitan Museum of Art, 1979.

Coats, Alice M. *The Book of Flowers: Four Centuries of Flower Illustration.* London: Phaidon Press, 1973.

Dunthorne, Gordon. *Flower and Fruit Prints of the 18th and Early 19th Centuries.* New York: Da Capo Press, 1970.

Foshay, Ella M. *Reflections of Nature: Flowers in American Art.* New York: Alfred A. Knopf, 1984. Reprint. New York: Weathervane Books, 1989.

Hulton, Paul and Lawrence Smith. *Flowers in Art from East and West.* London: British Museum Publications Ltd., 1979.

Mitchell, Peter. *Great Flower Painters: Four Centuries of Floral Art.* Woodstock, N.Y.: The Overlook Press, 1973.

Sterling, Charles. *Still-Life Painting from Antiquity to the Twentieth Century.* 2nd ed. New York: Harper & Row, 1981.